TO *the* CITY

TO *the* CITY

Urban Photographs of the New Deal

Julia L. Foulkes

TEMPLE UNIVERSITY PRESS
Philadelphia

Julia L. Foulkes is an Associate Professor of History at The New School and the author of *Modern Bodies: Dance and American Modernism from Martha Graham to Alvin Ailey.* With an interest in the broad impact of the arts, she has served as an advisor for the PBS documentary *Free to Dance* and various arts organizations and has edited a journal volume on "The Arts in Place."

TEMPLE UNIVERSITY PRESS
Philadelphia, Pennsylvania 19122
www.temple.edu/tempress

Copyright © 2011 by Temple University
All rights reserved
Published 2011

⊛ The paper used in this publication meets the requirements of the American National Standard for Information Sciences—Permanence of Paper for Printed Library Materials, ANSI Z39.48-1992

Library of Congress Cataloging-in-Publication Data

Foulkes, Julia L.
To the city : urban photographs of the New Deal / Julia L. Foulkes.
p. cm. — (Urban life, landscape, and policy)
Includes bibliographical references and index.
ISBN 978-1-59213-997-2 (cloth : alk. paper)
ISBN 978-1-59213-998-9 (pbk. : alk. paper)
ISBN 978-1-59213-999-6 (electronic)
1. Street photography—United States—History—20th century.
2. United States—Social life and customs—1918–1945—Pictorial works.
3. City and town life—United States—History—20th century—Pictorial works.
4. New Deal, 1933–1939. I. Title.

TR659.8.F696 2011
779'.473—dc22 2010018212

Printed in the United States of America

2 4 6 8 9 7 5 3 1

For Brian,
found in the city

Contents

LIST OF ILLUSTRATIONS

Photographs are reprinted from the Library of Congress, Prints and Photographs Division, Farm Security Administration/Office of War Information Collection. Access numbers are shown in parentheses. Captions in quotation marks are those created by the photographer and accompany the photograph in the FSA/OWI file.

CHAPTER ONE. INTERSECTION

CHAPTER TWO. TRAFFIC

CHAPTER THREE. HIGH LIFE AND LOW LIFE

CHAPTER FOUR. THE CITY IN THE COUNTRY

CHAPTER FIVE. CITIZENS

ACKNOWLEDGMENTS

I watched the Twin Towers of the World Trade Center collapse on September 11, 2001, from the rooftop of my apartment building in Brooklyn. While that day remains otherworldly, more subtle changes took place in conversations with friends over the next few months. One packed a bag and planned a route, ready to escape in the event of another attack; another resolutely ignored the threat and clung to normalcy. Most of us swung between those two poles, just unsure. My conversations with Jonathan Veitch pierced the ambivalence that suffused that time, because we inevitably wound up proclaiming our commitment to urban life, the diversity and cosmopolitanism that life in the city prompts, and—especially—the hope. On lunchtime breaks in Greenwich Village, walking past the telephone poles and walls plastered with photos of missing people, Jonathan and I found our way back to the city.

This book owes as much to those conversations with Jonathan as to the introduction he provided to Maren Stange, who, along with Alan Trachtenberg, hoped to produce a series of thematic books that would reveal the vast Farm Security Administration/Office of War Information photography collection to a new generation. Both Maren and Alan made important contributions to early ideas for this book, encouraging my contrary perspective on the urban in a collection of photographs devoted to the rural. Zane Miller then saved the manuscript from languishing in my filing cabinet, finding a home for it at Temple University Press. Zane, David Stradling, and Mick Gusinde-Duffy have been persistent and championing when needed most. I am grateful

also to others at Temple, to the anonymous readers, and especially to Lynne Frost for their help in bettering the book.

Colleagues at The New School have provided enormous inspiration on all things urban, especially members of our dedicated group in "The City" area of study, including Margarita Gutman, Rachel Heiman, Vlad Nikolic, Joe Salvatore, Jürgen von Mahs, and Aleksandra Wagner. Rachel Heiman offered particularly perceptive comments on an early draft of the manuscript, and Joseph Heathcott answered all of my random queries, with a bibliography *and* insight. I am grateful to these colleagues in urban studies at the university for their efforts to articulate and build a truly interdisciplinary approach to understanding cities, one that includes literature, policy, history, film, design, economics—and even photographs. And, in an instance of a teacher learning from her student, Ellen Tolmie has provided me tutorials on photography through her papers, her books, and her passion.

I found Brian Kane in the city; Brisa Foulkes Kane was born of it. There is no greater joy than to see the city through their eyes.

INTRODUCTION

~

Photographs of the Great Depression fill our repository of images of the American past, giving us a snapshot not only of the material characteristics of that era but of its values as well. Dorothea Lange's "Migrant Mother," perhaps the best known picture of the period, combines the fortitude associated with farmers with the pathos of struggle, bringing forward the mythical yeoman farmer into the unsettling circumstances of the twentieth century. Such photographs have shaped our view of the 1930s. Most of them were produced through the Historical Section of the Farm Security Administration (first called the Resettlement Administration), which was led by Roy Stryker, who sought nothing less than a detailed, panoramic documentation of American life by some of the best photographers of the era, such as Lange and Walker Evans. Their mission was to photograph rural Americans, to capture the receding of the country's agricultural sector, as farmers moved westward and toward urban centers.[1]

While the photographs helped make this passing of the agricultural era symbolic—and nostalgic—they also inevitably caught the irrepressible spread of urbanization, the march to the city. The early decades of the twentieth century marked a demographic shift in the United States from rural to urban, with the 1920 census revealing that the majority of Americans lived in an urban environment for the first time in the country's history. The Farm Security Administration (FSA) charged photographers to reckon with this change, to grasp a previous era and its values at a time when anonymous crowds, mechanized routines, and dense living encroached upon the countryside. Although

Stryker and the photographers he directed did not set out to capture the urban element of the transformation, it was unavoidable. "As the FSA file seizes the scene of the changing today, it will have within itself, and in proper perspective, the scene of yesterday," proclaimed John Vachon, who assisted Stryker in setting up the project and later became one of its more prolific photographers.[2]

But if the scene of yesterday was captured in "the changing today," so too was the scene of tomorrow—the propulsion to the city. Pictures of migrants showed a nation on the move, not just *from* the farm but *to* the city. Work, home, family, neighbors, leisure—these general categories of everyday life that shaped the shooting scripts of the FSA photographers—meant that pictures were taken of houses piled atop one another, factories and warehouses, movie houses and swimming pools, as well as a growing web of transportation that included streets, highways, cars, buses, trains, and planes. When the FSA documentation project was transferred to the Office of War Information (OWI) in July 1942, the pictures of cities increased as the aim shifted to showing a country ready for war, proud of its ability to mobilize and fight, and armed to defend its core principles.[3]

At its grandest, the scope of the project encompassed nothing less than the entire country, its past, present, and future, its emptied plains, struggling towns, and bustling cities. By necessity, Stryker narrowed that embracing scope to focus on the small town, which he saw as the "cross-roads where the land meets the city, where the farm meets commerce and industry."[4] This perspective reflected the influence of sociologist Robert Lynd, who, in his 1929 study of a small American city—later identified as Muncie, Indiana—sought to reveal the patterns of daily life by conducting interviews, analyzing demographic data, and knitting together values and beliefs alongside work, leisure, and community activities. Stryker sought out Lynd near the beginning of the FSA project, in early 1936, recognizing in the documentary detail of Lynd's book, *Middletown,* goals similar to his own for the FSA. Lynd quickly saw the opportunity the project posed and spurred Stryker to focus cameras on small-town life and core American values such as community and fortitude. On the train ride back to Washington, D.C., after his meeting with Lynd, Stryker wrote up a draft of a shooting script on small towns that was to become a permanent directive for all photographers in the field. It suggested photographs of everything from fire hydrants to "menus in windows" and "Post Offices—Unusual—humorous."[5]

While there were notable similarities between the investigative principles underlying *Middletown* and the FSA project, Lynd's publication of a follow-up study less than ten years after the original, *Middletown in Transition* (pub-

lished in 1937), betrayed unintentional parallels. Lynd was fully steeped in finishing the book when he met with Stryker, and he was woeful about the effects of the economic depression—and urbanization. Between the investigations in 1925 and those in 1935, Middletown's population had increased from around 36,000 to almost 50,000, with most of the growth occurring between 1925 and 1931. The small city had lost the town at its center. New buildings, bridges, an airport, a municipal swimming pool, brighter store fronts, more traffic lights: *Middletown in Transition* chronicled the social changes that accompanied the physical and demographic ones and, much like the FSA/OWI project, captured the range in the change, from town to city, from rural to urban.[6] The change may have dismayed both Lynd and Stryker, but they—and the projects they directed—could not make the march retreat.

Taken collectively, the FSA/OWI photographs of urbanization demonstrate the heyday of city life, when the country turned to the city with numeric force and expectancy.[7] Throughout the eighteenth and nineteenth centuries, Americans had looked askance at cities, more often seeing them as places full of problems—strangeness, duplicity, grime, and scandal—rather than places of equanimity and promising refuge. But alongside the lingering uneasiness about urban life in the early part of the twentieth century, cities took on new sheen as the site of mingling, opportunity, and hope. Written materials from various New Deal agencies, such as interviews conducted by the Federal Writers' Project and portrayals in the American Guide Series of states and cities, substantiate this brighter view of urban life, presenting detailed descriptions of what cities offered and the characters who resided there. The possibilities newly attributed to cities had their humble side, most evident in the photographs of the harsh housing conditions of the urban poor, as well as banality, shown in the increasing mechanization of city life. But the textual and visual materials relay the relentless sway toward urban life throughout the country: the density of people, buildings, cars, machinery; the mixing of strangers; the noise; the overriding of local culture by national culture; the pairing of hard work and raucous leisure. It is the city that represented the hope and renewal for the future rather than the farm itself or nostalgia for that rural past.

Our Cities: Their Role in the National Economy, a 1937 government report, confirmed the demographic change and analyzed its ramifications. The 1930 census classified places with 2,500 people as "urban," which may seem quite low by today's standards of concentration, but the report noted that the imperfect definition masked other demographic changes that coincided with urban living, such as a decrease in birth rate, a rise in average age, increasing mobility, and the consolidation of industry, trade, and wealth in metropolitan

areas. The substantive claim of urbanization lay in the numbers of people who resided in the ninety-six metropolitan districts that contained at least 100,000 inhabitants—45 percent of the population.[8] More indisputable than the numeric argument, the report linked rural and urban areas, arguing for their vital interdependence, although with the dominant flow going toward the cities: "the conditions of rural life today are therefore the preconditions of urban living tomorrow."[9] The report defended the link and the trend by noting the accompanying change in attitude toward cities:

> The city has seemed at times the despair of America, but at others to be the Nation's hope, the battleground of democracy. Surely in the long run, the Nation's destiny will be profoundly affected by the cities which have two-thirds of its population and its wealth. There is a liberty of development in isolation and wide spaces, but there is also freedom in the many-sided life of the city where each may find his own kind. There is democracy in the scattered few, but there is also democracy in the thick crowd with its vital impulse and its insistent demand for a just participation in the gains of our civilization. There is fertility and creation in the rich soil of the broad countryside, but there is also fertility and creativeness in forms of industry, art, personality, emerging even from the city streets and reaching toward the sky.[10]

With economic, demographic, social, and political trends oriented toward the city, Americans began to set their aspirations there as well.

The physical and demographic changes cloaked a more subtle shift: a new way of life forged in cities. In the early twentieth century, cities sparkled with vibrancy—flappers, cabarets, bohemians—which celebrated a lifestyle if not yet a way of life. By the 1930s, with the flash dimming, cities offered an allure less about excess and more about acceptance. The shift prompted attempts to define this new mode of living. Differentiating it from industrialism and capitalism, sociologists such as Louis Wirth and intellectuals such as Lewis Mumford focused on habits and attitudes that accompanied but could not be contained within the numbers that defined this new urban era. If size and density lay at the foundation of cities, such factors mattered less as isolated statistics than in their impact on daily life. Wirth described the heterogeneity of urban life that made city dwellers less dependent on particular individuals and more involved in a greater number of groups. The close living and working together of dissimilar people created a need for more order in a social world through such apparatuses as clocks and traffic signals. And the more atomized

collective life relied on visual recognition for personal alignment in the world, both physical and social. Seeing oneself meant seeing—and categorizing—people and places.[11]

Photographs, then, had a powerful role in creating and sustaining this new urbanism. Through an art form closely intertwined with urbanization since the nineteenth century, Jacob Riis and Lewis Hine in the early twentieth century employed photographs of cities to focus attention on brutish living conditions, while Alfred Stieglitz and Paul Strand displayed the city as a modernist spectacle. This urban focus was not surprising given that photographers themselves were, in general, people who already believed—and dwelled—in the city. This was also true of the FSA/OWI photographers, who knew little about rural life, a perspective that suited the project's initial aim of conveying the values and difficulties of the agricultural sector to city folks. "Everything seemed fresh and exciting" in the rural areas of the country, as photographer and "provincial New Yorker" Arthur Rothstein put it.[12] The city shaped what the photographers saw and ended up, at times, being the object at the end of the camera lens. Dorothea Lange described the change from being a portrait photographer to being a documentarian as a conversion prompted by the life outside her San Francisco studio:

> One morning as I was making a proof at the south window, I watched an unemployed young workman coming up the street. He came to the corner, stopped and stood there a little while. Behind him were the waterfront and the wholesale districts; to his left was the financial district; ahead was Chinatown and the Hall of Justice; to his right were the flophouses and the Barbary Coast. What was he to do? Which way was he to go?[13]

Lange left the studio and followed the man, eventually snapping in that walk one of her most famous photographs—men in a breadline—and found her photographic eye. Just a few years later, she was employed by the FSA, traveling around the country, even though she "didn't know a mule from a tractor."[14] Photographers found their livelihood, ambition, colleagues—and vision—in the city, and they reflected the views of those already ensconced there: progress, survival, and inspiration lay in the dense maze of people, industry, and commerce.[15]

While movies emerged as a new visual mode of urban life in the 1930s, photographs still carried potency. The still image could gather lasting iconic strength that the moving image could not. A 1968 exhibit of FSA photographs

of urban life demonstrated this enduring power. In an effort to resuscitate more innocent urban images at a time when cities were burning and crumbling at an appalling pace, the exhibit put forth a broad definition of urbanism—"the hand of man maintaining control over the forces of nature"—and featured fewer cities and more towns. Less notable than the actual photographs, however, was the admission of the urban element in FSA's project, which had been defined and promoted as capturing only rural and small-town life. "I wanted to get more city pictures, but we just couldn't get them. That was a little bit further than we could dare go," Roy Stryker noted in the catalog, alluding to the thematic concerns that structured the financing of the project under the Farm Security Administration.[16]

The mission of the project was one thing, the result another. Stryker and the photographers sought to make concrete to city folks the devastation of rural life, yet the pictures also conveyed the dawning commonness of urban life. The Depression progressed incrementally—not a dramatic instance of change, such as a hurricane or a fire, but a wearing down into habit that became difficult to see in its full consequence. Photographs mattered, then, in seeing this transformation. Both to people then and to us now, they show the depth of the impact of the Depression and urbanization on daily life throughout the country, giving in grainy detail the look and feel of living in dirty tenements, communing in public parks, and being surrounded—and anonymous—on a crowded sidewalk. In an era when words were the primary medium of news—via radio, newspapers, and conversation—the potency of an image stood out. The migration from the dustbowls as well as the dense tangle of city life became certain and tangible in the static, iconic images of the FSA/OWI collection. The photographs focused the statistics and words of this societal change, attaching human images to the numeric and verbal ones. These are people and places captured in time, fixed but full, caught in a moment that holds the push of the past and the propulsion into the future.

The array of urban life presented in the almost 170,000 photographs of the FSA/OWI collection from 1935 to 1944 ranges from portraits of taxi drivers to parades, train stations, and housing conditions. The photographs offer ample record of the material of daily life in the city—the clothes, workplaces, signage, shopping, transportation—but they also convey broader themes that structured urbanization during the era and form the categories of images in this book: Intersection, Traffic, High Life and Low Life, The City in the Country, and Citizens. These categories attach broad characterizations of modern urban life to a historical moment. Traffic, for instance, relays the congestion at

a city's core, newly mechanized in the 1930s with the wider distribution and use of cars. The FSA/OWI project was a seminal moment in the history of photography in the United States, but the photographs also serve as evidence of this moment in urbanization, visualizing the look and feel of the transformation that formed the basis of our city life today. Descriptions from the photographers, accounts from the American Guide Series of states and cities, as well as interviews conducted by the Federal Writers' Project amplify these themes, adding another layer of interpretation and magnifying the impact of this change. The Federal Writers' Project, one of four sections of the Works Progress Administration (WPA) aimed at employing the nation's artists (the others were Art, Theater, and Music), paralleled the aim of the FSA/OWI in that writers and interviewers intended to amass a holistic vision of the country, often highlighting its diversity but presenting a unified picture nonetheless. The American Guide Series, in particular, brought together a collective of writers and researchers that gave a comprehensive overview of the history, geography, demographics, amusements, and unique attractions of a state or city. The WPA's bureaucratic organization (federal oversight of regional and local offices) as well as its ideological orientation toward unity reflected the values of most New Deal agencies and even of the era itself.[17]

The guides and the photographs obscured the political nature of much of the artistic and cultural work of the era, depicting a desperate and tempestuous time through a more harmonious frame. In government-funded ventures, politics had vital consequences, as the Federal Theatre Project discovered in 1939 when its funding was stopped largely because accusations of communism and socialism shriveled congressional support. The government-sponsored artistic works of the era, however, were at the cautious end of a more comprehensive movement to infuse the arts with social purpose, from the songs of Woody Guthrie to the films of Will Rogers and the jazz of Benny Goodman and Duke Ellington.[18] Stryker negotiated the FSA/OWI photographers through this political landscape by keeping the focus on ordinary folks and largely staying away from the potent issues of the day, including race relations. The pictures, some quite stark, remained more impressionistic than pointed.

That suggestive rather than targeted approach appears to have guided the appearance of cities in the photographs as well. Specific cities dominated (New York, Chicago, Baltimore), while others received rather little attention (Philadelphia, Milwaukee, San Francisco, Miami), even as the emergence of certain regional centers (Phoenix and Omaha) marked the shift from eastern to western seaboards.[19] As the mission of the FSA project changed in the OSI years to document the wartime build-up, images increased of industrial centers—generally in the east, although certain cities in the west stood out for their

growing defense industry (Seattle) or for their specific social repercussions, such as the resettlement of Japanese Americans (Los Angeles). While this scattershot approach may have guided the photography of urban scenes, the cataloguing of the photographs solidified the prominence of them. The classification system developed in the early 1940s enumerated general categories for filing that began with "The Land—The Background of Civilization" immediately followed by "Cities and Towns." The entire corpus of photographs was broken down by region, with each region featuring file drawers full of pictures of "Cities and Towns," narrowed into a myriad of focused designations such as city streets, stores, waterfronts, parks, transportation, religion, and intellectual and creative activity. In a search through the physical files of photographs at the Library of Congress and the online catalog of images, it is easy to see that urbanization spread unevenly and differently, but with a striking sureness.[20]

As I searched for the societal story in these photographs, searing images of aesthetic quality sprinkled throughout could not be ignored. My final selection took into account both the representativeness of the content as well as the quality of the image. If the pictures represent a range of visual precision and artistry, then they likely reveal the ways we see in everyday life, absorbing mundane, blurry scenes alongside those of startling clarity and effect. In this focus on the customary and the habitual, the FSA/OWI photographs made urban life common. Photographers who followed then pushed off that benchmark to present the unvarnished and the strange, such as Weegee's (Arthur Fellig's) view of the *Naked City,* which appeared in 1945. By then, the FSA/OWI collection had trained our eyes to look more closely at scenes around us and to revel in the profundity of even our most casual moments.

Cities in the United States have been and remain gateways to participation in the world. As transportation, communication, cultural, and work hubs, they animate the nation, reeling in to them people from the country and other parts of the world. If their force has been magnetic, it has not been undisputed or constant. Even as early as the end of the 1930s, suburbs became the new vision of a better life. Federal and private investment turned dramatically to support growth in the suburbs after the war, from the mass housing tracts of Levittown and other such developments to the federal highway act that constructed roads to get around cities and to outlying areas. That investment prompted the decline of the city center, which became overwhelming by the 1960s, a devastation that has been unevenly overcome only by the end of the twentieth century.

If the role of cities in world affairs has come to be a tenser one since the 1930s and '40s, through the crisis of the 1960s and '70s to today's terrorists'

schemes, it is useful to remember when and how cities have also been the focus of opportunity and aspiration. Before the beginning of the Cold War and the boom of the suburbs, cities offered the hope that work could be found and could be satisfying, leisure could be exhilarating, and strangers and strangeness could be made common. We may look askance at that wide-eyed embrace now—knowing what has come after—but cities may glow brightly in our eye again. The deepening environmental and fiscal crises have tarnished the benefits of exurban and suburban areas. The dense, compact, and resource-efficient habits of urban life may prompt a renewed embrace of urbanism.

The photographs in this collection relay the daily embrace of urban life in the 1930s and early 1940s. They give grain, tone, and detail to the pronouncements and the larger societal swing toward life in the metropolis, whether in residence or in the imagination. As a passage from the Cincinnati guide put it, the city "is compounded of the hundreds of familiar pictures that day by day seep into the consciousness of those who live here":

> Sunlit hills and window panes twinkling down the end of a street. Shore lights and moonglow on the river at night. Rows of rooftops up the valleys like stone flagging among the grassy tops of trees. Gaslit streets lined with tall hedges and trees so thick that sidewalks long ago were laid around them. Bright rock gardens and sloping lawns. Massive brick and stone homes, some high above the street, others far below in some wild and lonely ravine.
>
> Women in house dresses leaning far out over window sills to catch a few gasps of air in humid summer afternoons. Writhing children, sputtering and laughing under the cold spray of a sprinkler attached to a sidewalk fire plug. Plump housewives armed with baskets and shopping bags waddling through crowded market houses. Men with lunch kits walking up steep flights of concrete steps to their homes. Families with noisy children bound for Coney Island amusement park on the river steamer, *Island Queen*. Shoppers waving familiarly to passersby across the way on downtown streets. Groups walking down to Old World eating places in basements. Couples sipping brew and ale in outdoor beer gardens. Men in formal wear and stunning women in evening gowns trailing over to Music Hall for the symphony. Urchins throwing pop bottles at the umpire over at Crosley Field.[21]

"That is Cincinnati" ends the passage. It might as well have said, "This is a city."

1

INTERSECTION

~

ontrasts mark a city. Old folks encounter young ones; strangers mix
with neighbors; new buildings spring up among old; signs, people,
buildings, animals compete for attention; people from different jobs
and backgrounds cross paths. The intersections of these contrasting elements
provide much of the verve of city life, but the most basic intersection in a city
is that between streets. A crossing of streets literally allows one to tack in a new
direction, to move from one place to another; it often provides a moment of
slowdown or a stop in the course of moving along one's way. Photographs not
only depict this geographical condition but convey a mental one as well. From
the sweep of a nighttime street in downtown Dallas with its shimmering lights
to the sharp angularity of the corner of Macy's at Herald Square in Manhattan
and the smoother curve of a corner in Phoenix, the intersections of city streets
link the arteries of a city, the paths that make circulation and mobility possible
(Figures 1.1–1.3).

The physical plan of street intersections in urban space reveals a geometric
pattern of related shapes when seen in aerial view (Fig. 1.4). But, on the ground,
the patterns set up the random crossings of people in urban life. Pictures of
this human intersection pulse with poignancy, displaying the "what if" and
"maybe" and "why not" of the whimsy of convergence. The photograph freezes
these possibilities, allowing the imagination to play out what might have hap-
pened next, and the visual frame replicates at least some of the chance of the
moment. It is as if parade onlookers in Cincinnati—African American boys
perched atop a structure and a white mother and kids seated below, looking

every which way—might soon begin to see one another and strike up a conversation (Figure 1.5). More often, though, the pictures of intersecting people show disengagement from persons nearby (Figure 1.6). With backs to each other on a park bench, two women eat lunch and read newspapers, nearly touching—and yet each absorbed in her own personal world (Figure 1.7). Two African American women in downtown Houston, photographed in mid-conversation, are fully engaged, amid a sea of others with their eyes elsewhere. Out of the busy flow of the sidewalk, only one man in the background seems to notice the photographer (Figure 1.8). A street hawker interrupts the path of walkers, hoping to make a momentary connection (Figure 1.9). Haphazard crossings invite disregard or engagement.

Intersections form corners where collisions—of all sorts—can occur. The photographs of people passing by, gazing elsewhere, nearly crashing, suggest both what could happen by surprise and what one might miss by looking the other way. The mobility and near-collision associated with intersections and streets, though, mask the ways in which corners are stable markers, a moment of knowing where one is even if it is impossible to know what will next be encountered (Figures 1.10–1.12). The shadowed picture of a corner under the elevated trains in Chicago suggests such nuance, revealing the layers of intersection that occur moment to moment—up above by train, below in the street by car and trolley, and on the sunlit sidewalk by pedestrians. Light pierces the corner, spotlighting some parts of the intersection while others remain in the dark (Figure 1.13). Certainly one of the tantalizing aspects of city life is the isolation of events. Something can happen on one block and, right around the corner, there may be no awareness or consequence of it. Corners conceal what else is going on by limiting what one can see. A commentator described the plight of African Americans in Washington, D.C., emphasizing just this conjunction:

> When the outsider stands upon U Street in the early hours of the evening and watches the crowds go by, togged out in finery, with jests upon their lips—this one rushing to the poolroom, this one seeking escape with Hoot Gibson, another to lose herself in Hollywood glamor, another in one of the many dance halls—he is likely to be unaware, as these people momentarily are, of aspects of life in Washington of graver import to the darker one-fourth. This vivacity, this gayety, may mask for a while, but the drastic realities are omnipresent. Around the corner there may be a squalid slum with people jobless and desperate; the alert youngster, capable and well trained, may find on the morrow all employment closed to him.[1]

The limited vision that corners and other aspects of the city present, combined with the exponential possibilities, creates the enticement of city life. The downward tilt of a street in Seattle juxtaposed with a sign at a dramatically different angle offering outfitting for Alaska conveys a slightly off-kilter orientation (Figure 1.14).

The conjunction of urban elements comes across powerfully not just in spatial crossings but also in the ways photographs frame opposites. John Vachon's picture of the Abraham Lincoln statue in Milwaukee joins the monumental with the common (Figure 1.15). Russell Lee's picture of an elderly man in front of the "old" Columbia Hotel, "Always Kept New," relays one of the most consistent clashes in urban life in the 1930s—the old and the new (Figure 1.16). Like a cross-sectional architectural view, John Vachon captured the layers of cities, with new buildings atop crumbling ones (Figure 1.17). In Cincinnati, a rear view of row houses displays the outhouses still in use, as they stand almost proudly, showing the back side of city life to the passengers on trains traveling the tracks below. The outhouses teeter in a city caught between its past and its future (Figure 1.18). Similarly, a factory emblazoned with its city's name has broken windows in its grand but crumbling facade (Figure 1.19). On another building, a peeling billboard telescopes the collision of old and new as aged layers bubble below the surface, disrupting the images of a possible romantic encounter in the top layer. Doors can be seen beneath the layers of advertising, suggesting an entry to a hidden place once papered over but breaking forth again in the decay (Figure 1.20).

On a 1941 trip to Chicago, the photographer John Vachon wrote a letter to his wife that captured the frisson barely contained in the intersections at the core of urban life:

> How sad, to leave Chicago. I have had a wonderful week, and such dandy fun, and seeing so much going on—cab drivers looking at maps of Russia, and arguing about the way, one guy points and says that's where his old man comes from. And all the snotty dames on Michigan Ave. that I want you to emulate. And a cop with a heavy Irish in the talk that everyone says—Hello Barney—to on his way home. I followed him 8 blocks. He was just like in the movies. Then all the joints are so nice, and the clean cafeterias, and living here with a radio in your room, and swimming with the sun hot. Jeez I like it. And the gal in the stockyards office who said "you can tell which way the wind is blowing by whether you smell pig shit, cow shit or hog shit". . . . Then just walking up and down the streets, the big buildings with lights on them, nice new stuff in windows, Chinatown. O give it to me, give it to me.[2]

Vachon, in his embrace of urban collisions, was more celebratory than others among the FSA photographers. Sheldon Dick's photograph of a "Street in [the] Negro section" of Baltimore reveals more ambiguity (Figure 1.21). It shows a road shorn of niceties, with a broken bike in the background and lopsided shutters hanging on a long window. The two people in the photograph present different views of street life. The person in the background stares down a street not visible to the camera with an unfocused gaze that may characterize people who are left to run out time by neglect or misfortune. The other person faces the camera directly and with a slight smile, looking ready to push off from the stoop—an inviting, even hopeful, posture despite the apparent misery of the surroundings. Between the figures the corner features a crumbling building with boards across its facade that are overlaid by a faded sign bearing a large crab, binding the two together—in misery and in hope—in an urban intersection and a symbol of the city.

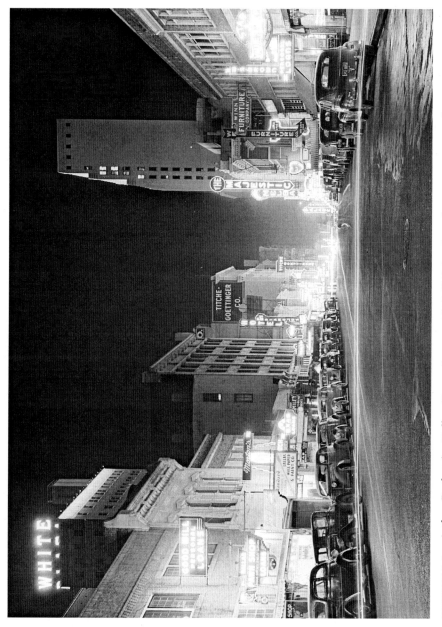

FIGURE 1.1 Arthur Rothstein, Dallas, Texas, January 1942. "Night view, downtown section."

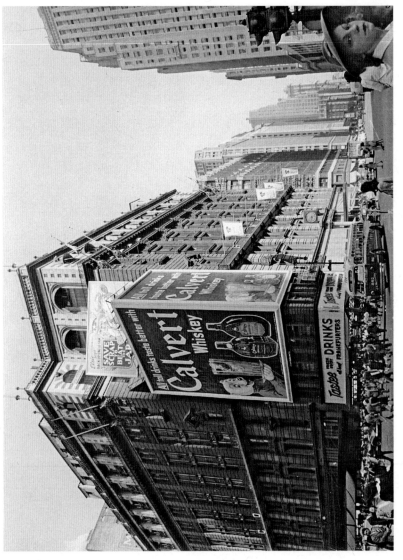

FIGURE 1.2 Marjory Collins, New York, New York, September 1942. "Macy's department store at Herald Square." The buildings appear to angle inward, dwarfing the bustle of the street, but the knowing gaze of the woman in the lower right corner refutes the threat of the towering cityscape.

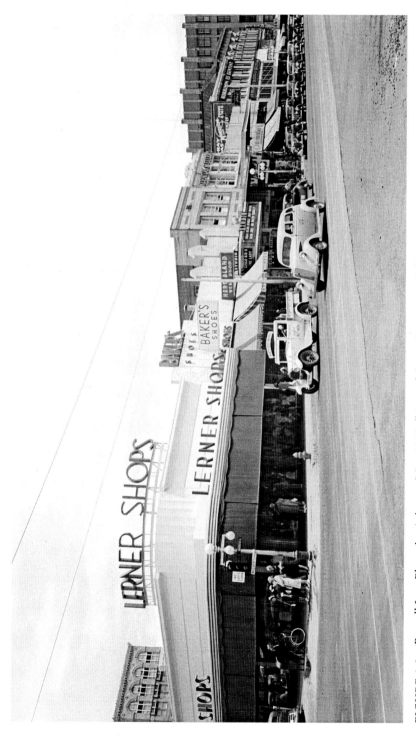

FIGURE 1.3 Russell Lee, Phoenix, Arizona, May 1940. "One of the main streets of Phoenix, Arizona. Phoenix is the center of the Sun Valley, an intensely irrigated and cultivated district." The rooftop sign follows the curve of the building and the street corner, dramatizing this intersection in one of the rapidly expanding western cities.

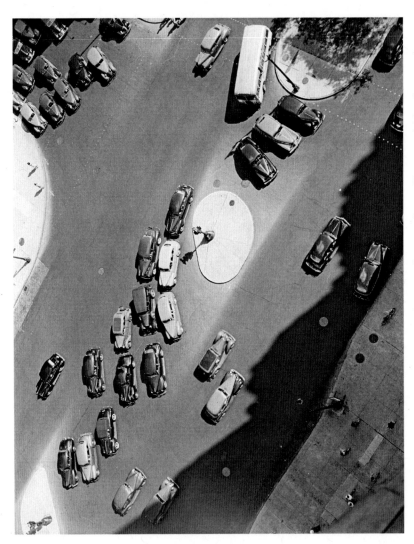

FIGURE 1.4 Arthur Siegel, Detroit, Michigan, July 1942. "A traffic control island around which the traffic moves in several directions." As car traffic increased, intersections became even more confusing before new rules and habits began to take hold.

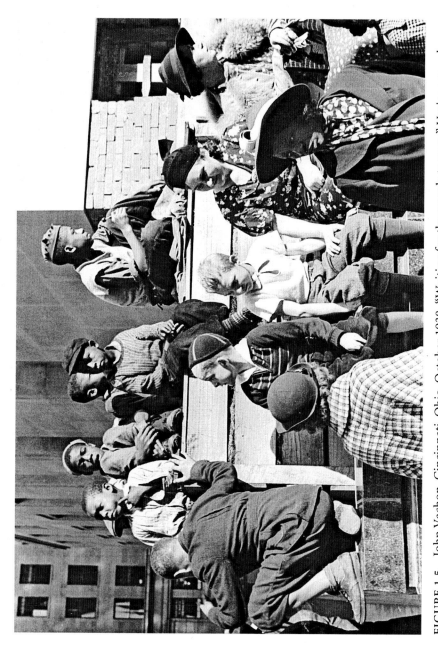

FIGURE 1.5　John Vachon, Cincinnati, Ohio, October 1938. "Waiting for the parade to pass." Various people are brought together in a city celebration (a sesquicentennial parade), yet all are looking different ways.

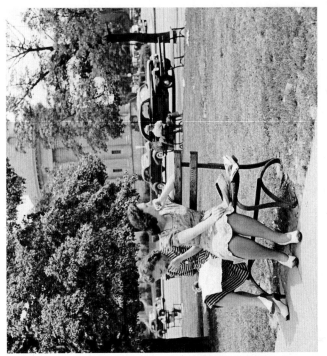

FIGURE 1.7 John Ferrell, Washington, D.C., May 1942. "Sunday in the small park at 16th and Harvard Streets."

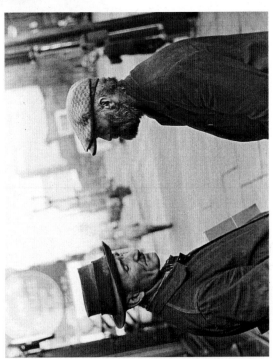

FIGURE 1.6 John Vachon, Omaha, Nebraska, November 1938. "Lower Douglas Street, Omaha, Nebraska." Two men, both grizzled and beat, face but look past each other.

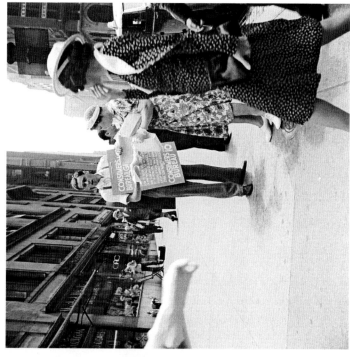

FIGURE 1.9 Dorothea Lange, New York, New York, July 1939. "A street hawker selling Consumer's Bureau Guide on 42nd Street and Madison Avenue." A gloved hand reaches into the frame of the photo on the left, as interruptive to the view as the street hawker may have been to the crowds on the sidewalk.

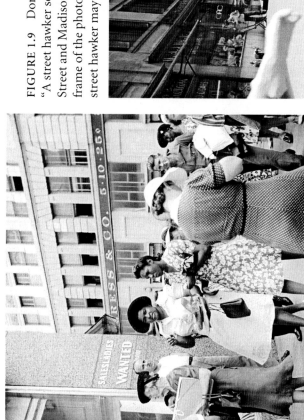

FIGURE 1.8 John Vachon, Houston, Texas, May 1943. "Shoppers." The sign "Salesladies Wanted," a held shopping bag, and the stream of people reveal the economic activity revived by the war effort.

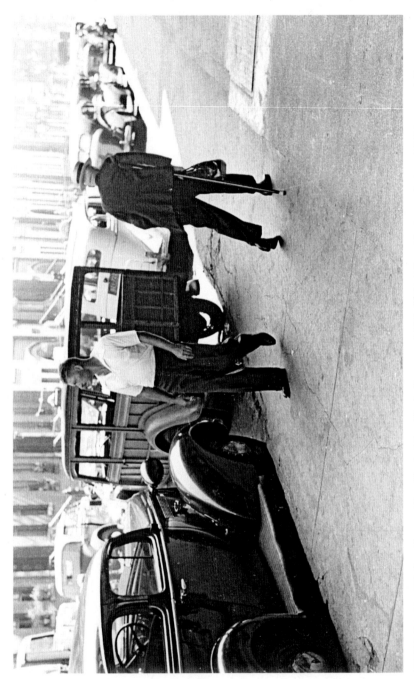

FIGURE 1.10 Walker Evans, New York, New York, Summer 1938. "[61st Street between 1st and 3d Avenues]." Just as Evans captured the nonchalance of constant crossing in the city, a truck with its rear end at the sidewalk in between parked cars looks both accidental and normal in the wide range of what is possible.

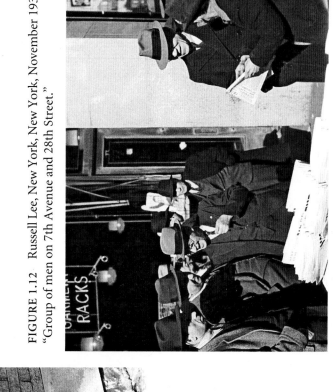

FIGURE 1.12　Russell Lee, New York, New York, November 1936.
"Group of men on 7th Avenue and 28th Street."

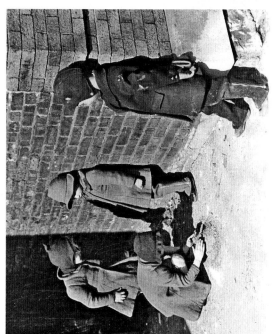

FIGURE 1.11　Russell Lee, Chicago, Illinois,
April 1941. "This is where the Negro and White
sections meet on the South Side. The White and
Negro children sometimes play together."

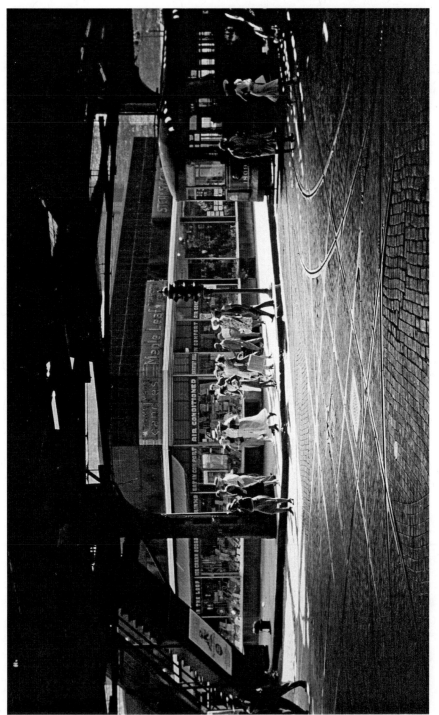

FIGURE 1.13 John Vachon, Chicago, Illinois, July 1940. "Under the elevated railway."

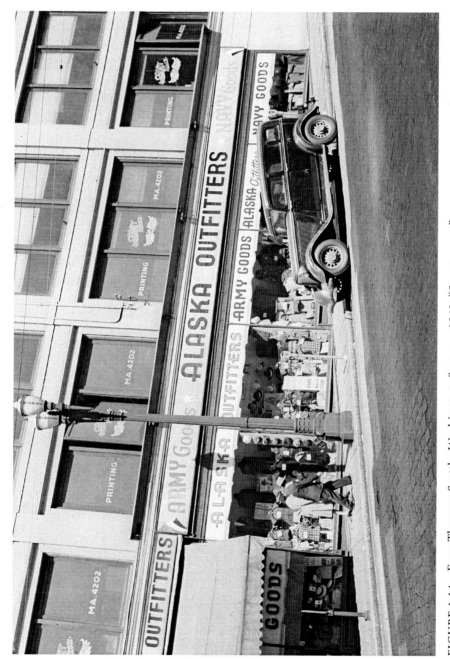

FIGURE 1.14 Evan Thomas, Seattle, Washington, Summer 1943. "Street scene."

FIGURE 1.15 John Vachon, Milwaukee, Wisconsin, September 1939. "Park scene, Labor Day."

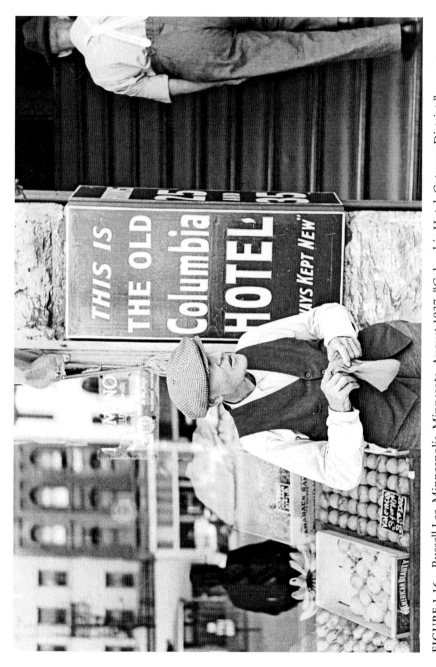

FIGURE 1.16 Russell Lee, Minneapolis, Minnesota, August 1937. "Columbia Hotel, Gateway District." The grocery store window catches the reflection of the other side of the street, adding to the collision of images.

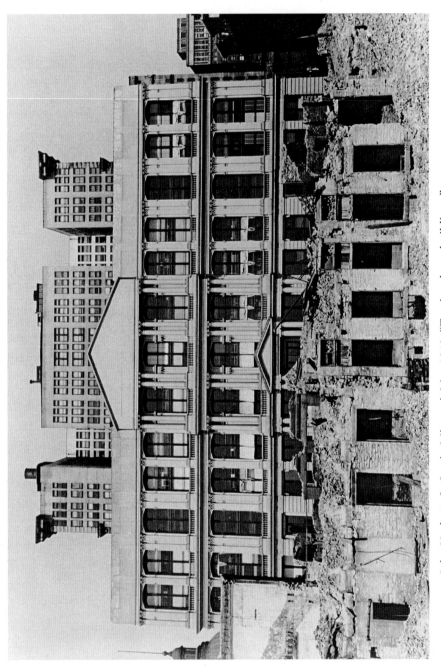

FIGURE 1.17 John Vachon, St. Louis, Missouri, May 1940. "Tearing down buildings."

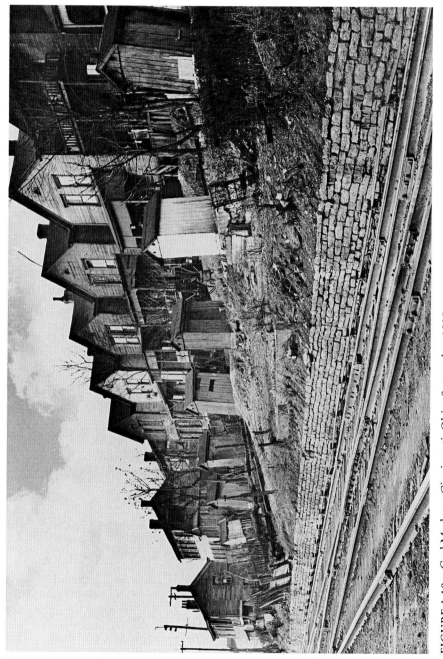

FIGURE 1.18 Carl Mydans, Cincinnati, Ohio, September 1935.

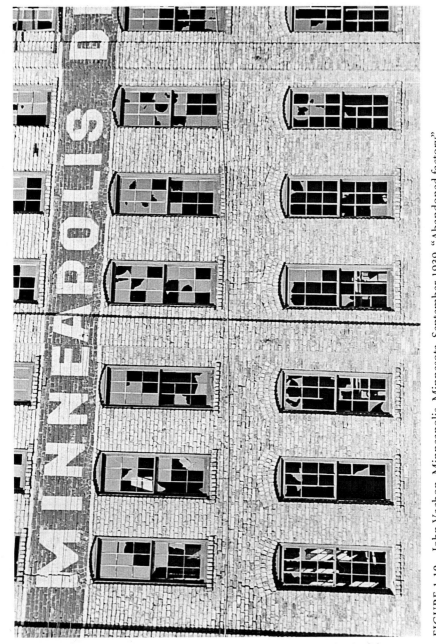

FIGURE 1.19 John Vachon, Minneapolis, Minnesota, September 1939. "Abandoned factory" proclaims its city's name and the despondent times.

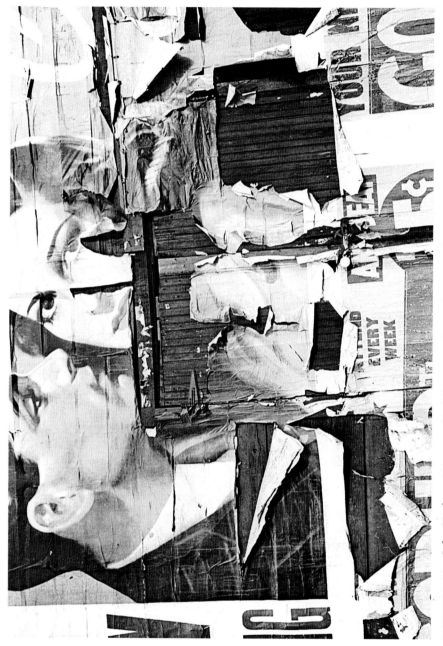

FIGURE 1.20 John Vachon, Minneapolis, Minnesota, September 1939. "Tattered billboard."

FIGURE 1.21 Sheldon Dick, Baltimore, Maryland, July 1938. "Street in Negro section."

2

TRAFFIC

~

From aerial photographs to pictures of human encounters, random and intentional, images of intersections reveal the enduring qualities of city life—the diversity and busyness of its streets. The photographs in this chapter compress the intersections at the heart of urban life to their mechanized level. A shooting script by Roy Stryker, in fact, included "Intersections" and identified those that demanded photographers' attention as "Cross Roads; Side Roads; Cloverleaf Passes; Over and Under Passes."[1] While roads and highways appear throughout the FSA/OWI collection, a pair of photographs exemplifies the primacy of people in the traffic of the urban landscape. The first of the photographs from 1941 reveals Times Square in Manhattan on a December morning, bustling and full; the second, five minutes later, shows the same place barren after the sounding of a test alarm for air raid protection. The photographs record the entrenchment of wartime exigencies in daily life—and they also show the vitality that traffic creates. If crossings and clashes form the basis of opportunity in cities, then the density of crowds, cars, events, machines, and buildings makes such chance meetings possible (Figures 2.1, 2.2).

The photographs in the FSA/OWI collection reveal—even magnify—a characteristic new to cities during this era: cars. As the automobile became a defining element of American life, cities changed to accommodate this new machine that increased mobility but also overtook streets. Washington, D.C., led the nation in the largest number of automobiles per capita of any city, with more than one car to every three people, although Detroit followed in second

place and would have led if cabs had been excluded, because, in the motor city, "owning a car is more important than having a telephone or owning a radio."[2] The number one concern for the people of *Middletown* by 1935 was to improve traffic conditions by increasing parking facilities, widening streets, and constructing highways.[3] In the growing congestion, traffic regulations became elaborate and noticeable, such as those governing Atlanta: "Speed limit 25 m.p.h. Right turn permitted on red light after full stop; left turn on green light only. Signs by traffic lights mark intersection where no left turns are permitted. One-way streets marked by arrows. Signs indicate where parking is permitted in downtown area; parking on right of street enforced even in residential section."[4] Traffic lights, speed signs, stop signs, traffic cops, medians, painted lines on the streets—all of these added to the visual landscape of intersections and city streets (Figure 2.3). While making the vista more crowded, these new elements also were focused more on the driver than on the walker. Pictures of recently populated cities show broader and bigger signs, aimed at attracting the attention of people moving from a distance at a faster speed.

Cars became not just notable objects in the city but shaped its landscape: cars roll single-file down streets, waiting expectantly at a red light or lining one side of the road in rush hour; parking lots rim city centers; parked cars along metered slots set up a rhythmic pattern, a harmonic arrangement dependent on the uniform car styles of the era (Figures 2.4–2.6). While earlier pictures featured the weaving of people around cars, later photographs presented cars alone, as beings in their own right (Figure 2.7). People are not just squeezed by cars, but eclipsed. And cars became a base of the horizon, as in Washington, D.C., with its "imposing mass of masonry along Constitution Avenue . . . visible only through an encircling string of cars. . . . Day and night endless lines of cars flank the streets of Washington, which are further disfigured by a procession of signs intended to control this nuisance."[5] The impact of cars and all they required prompted Roy Stryker to ask photographers to shoot highways, recognizing that the "American highway is very often a more attractive place than the places Americans live."[6]

Other forms of transportation add to the scene—railroads, boats, buses, streetcars, subways—necessitating massive infrastructure such as train tubes, subway tunnels, water mains, gas and electric conduits, telegraph and telephone wires, and sewers below ground that underlay the tracks, electric lines and poles, drawbridges, and gas stations above ground (Figure 2.8). Photographs depict the merging of the aboveground elements in one scene, the pedestrian vying with a car that is meeting up with a streetcar, with poles, lights, and signs tangled above it all (Figure 2.9). If sound accompanied these

photographs, one would hear the rising din, constant but punctuated by honk-
ing horns, screeching wheels, and the cries of hawkers (Figure 2.10). And the
scene inside the public transportation vehicles mirrored the jumble outside. A
look at a streetcar caught the jostling throng of people inside: men and women
in hats staring stoically ahead, with the steady, clear-eyed gaze of an African
American woman in the middle piercing the crowd (Figure 2.11).

The density of urban life went beyond the transportation web that pro-
vided mobility to people into, out of, and around the city. Houses abutted one
another, soon climbing atop one another in the hills of Pittsburgh, for exam-
ple, and competing with looming billboards (Figures 2.12, 2.13). The detritus
of density also became more apparent, as old cars and car parts filled back-
yards alongside trash and lumber, and more and more stuff added to the
thickening foundation of urban life (Figures 2.14, 2.15). Photographs of the
backs of buildings show the layers of living spaces and lifestyles that began to
accumulate (Figure 2.16).

Perhaps the most poignant photographs of this congestion are the ones of
waiting: cars and people waiting at traffic lights; people waiting for buses, trains,
or airplanes to arrive; lines of people waiting in front of soup kitchens or out-
side employment offices (Figures 2.17–2.20). As much as mobility defined the
era—moving from farms to towns, from east to west, from south to north—
delay often overshadowed the movement. People were waiting for change,
for jobs to come forth, for food, for government assistance—for this painful,
often shameful, period to end. "Old Tom," a homeless and jobless horse driver,
lamented the shift to cars, defending "Old Jerry," the horse, who "knew all the
traffic rules and unlike a lot of people drivin' automobiles and motor trucks
these days, he never broke any of them." Even more, Old Jerry had "horse
sense" and knew not to waste time fretting about the future; Old Tom, on the
other hand, had been waiting for the future for a long time and suddenly
found it had sneaked up on him and put him alongside a "row of garbage
cans."[7] Traffic was not just about new signs and lights and vehicles but new
restrictions as well, social and mechanical. Cities radiated that mind-set of
waiting for change, augmenting the mental outlook of uncertainty and delay
with the physical burden of lines for everything from food to travel. Although
the density and traffic of cities offered possibilities, waiting offset that hope,
dimming the luster of opportunity.

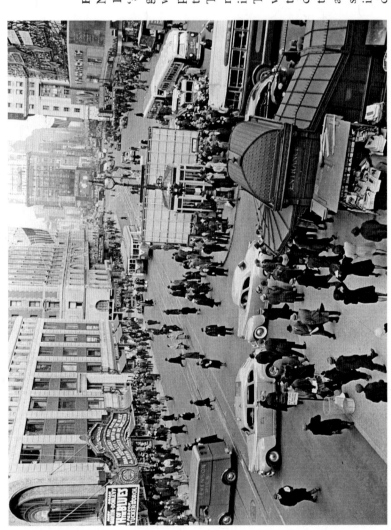

FIGURE 2.1 Howard R. Hollem, New York, New York, December 1941. "Air raid protection. Test 'alarm.' [Figures 2.1 and 2.2] tell graphically what can be done when civilian defense officials, police and public all co-operate to make an 'alarm' successful. These pictures were made on the morning of December 15, 1941, in Times Square, New York City. The time interval between photos was exactly five minutes. Within this time, in one of the most crowded metropolitan areas in the world, it was possible to stop all traffic, and to get all persons safely indoors. Those few remaining on the street are civilian defense officers (wardens, etc.)."

36

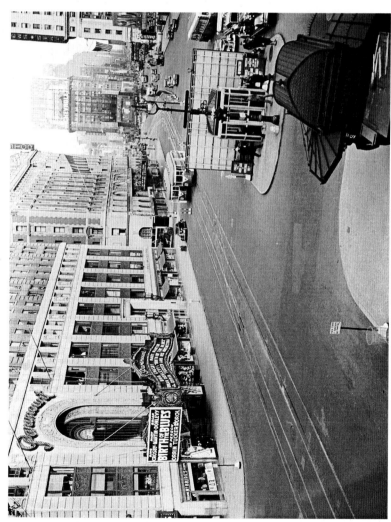

FIGURE 2.2 Howard R. Hollem, New York, New York, December 1941. This is the street scene after the air raid alarm; see Figure 2.1 for the view before.

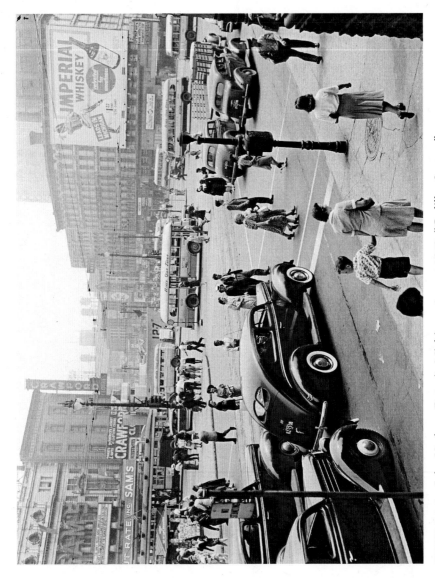

FIGURE 2.3 John Vachon, Detroit, Michigan, August 1942. "Cadillac Square." Signs, traffic lights, cars, trolley, a pickup truck, and pedestrians tangle.

FIGURE 2.4 John Vachon, Chicago, Illinois, July 1941. "Stoplight." Cars square off at an intersection, as if at the starting block of a race.

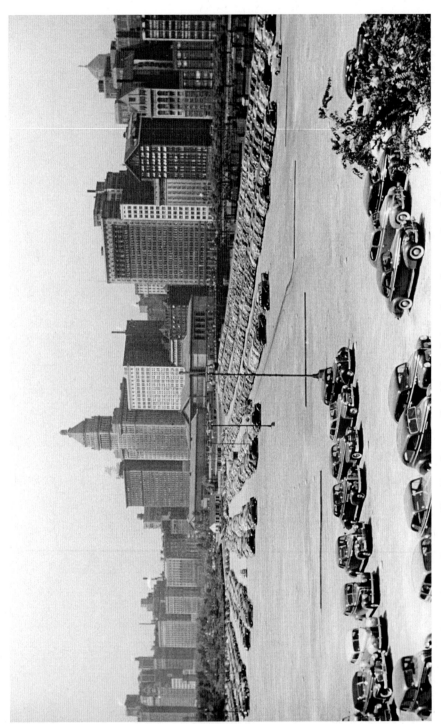

FIGURE 2.5 John Vachon, Chicago, Illinois, July 1941. "Parking lot." Cars form the new rim of the city.

FIGURE 2.7 John Vachon, Chicago, Illinois, July 1941. "Parking lot." Cars cover the ground.

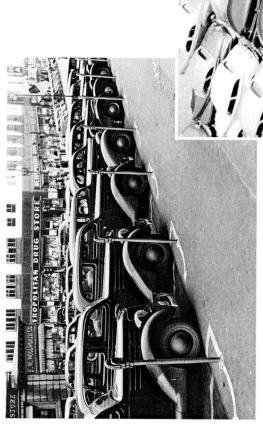

FIGURE 2.6 John Vachon, Omaha, Nebraska, November 1938. "Cars parked diagonally along a row of parking meters."

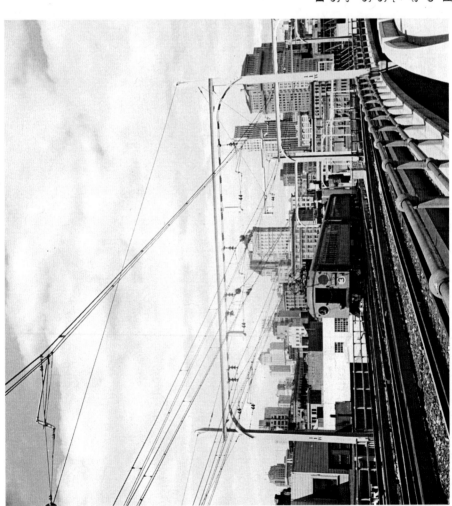

FIGURE 2.8 Dorothea Lange, San Francisco, California, April 1939. "The city of San Francisco, California. Seen from the first street ramp of the San Francisco Oakland Bay Bridge." Traffic occurs not only on roads but also in the air, with crisscrossing electric lines creating another tangled path to the city.

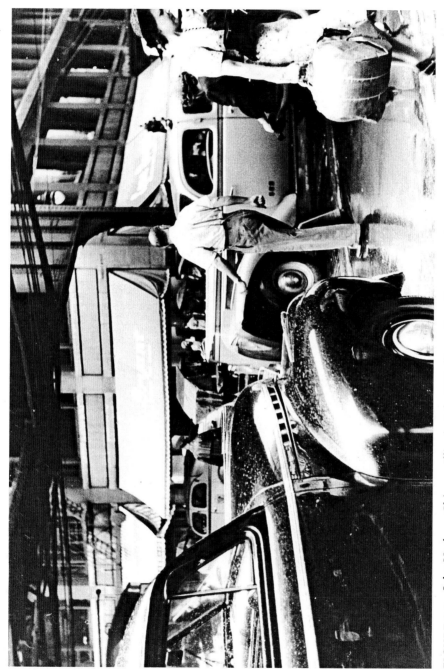

FIGURE 2.9 John Vachon, Chicago, Illinois, July 1941. "Jaywalkers."

FIGURE 2.10 Russell Lee, New York, New York, November 1936. "Hair tonic salesman advertising his wares, 7th Avenue at 38 Street," adding to the bustle.

FIGURE 2.11 Marjory Collins, Baltimore, Maryland, April 1943. "School children and workers returning home on a trolley at five p.m."

FIGURE 2.12 Arthur Rothstein, Pittsburgh, Pennsylvania, July 1938. "Houses along Monongahela River and Boulevard of the Allies," climbing up the hill.

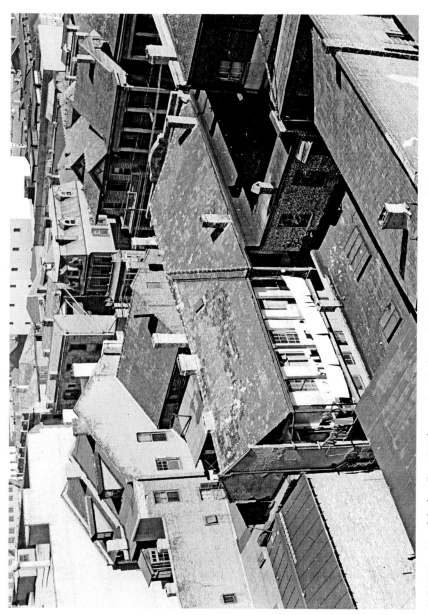

FIGURE 2.13 Marion Post Wolcott, New Orleans, Louisiana, January 1941. "Old buildings." A bird's-eye view reveals a puzzlelike pattern of tattered roofs, different shapes nestled next to one another.

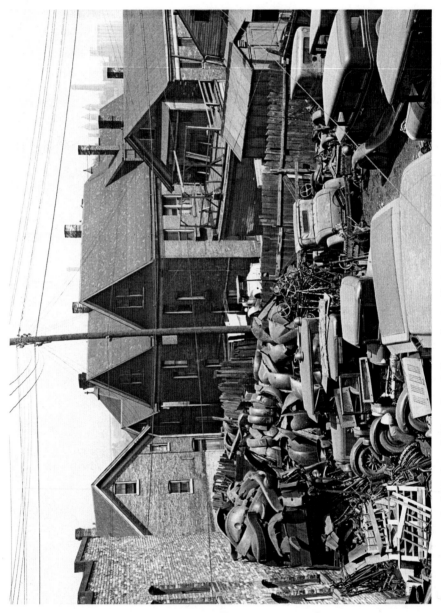

FIGURE 2.14 Carl Mydans, Milwaukee, Wisconsin, April 1936. "Junk, with living quarters close by."

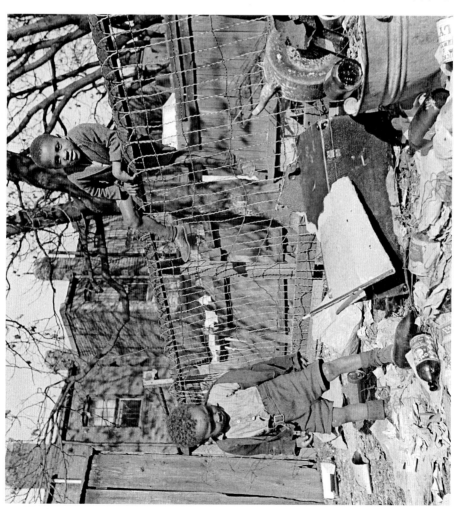

FIGURE 2.15 Gordon Parks, Washington, D.C., November 1942. "Two boys playing in their backyard."

FIGURE 2.16 Carl Mydans, Milwaukee, Wisconsin, April 1936. "Rear of apartments at 8th and Wisconsin, with Milwaukee Public Library in background." This image presents a symbolic vision of the crumbling of society, no longer kept out of sight, even if blurred by smoke (as in the center of the photograph).

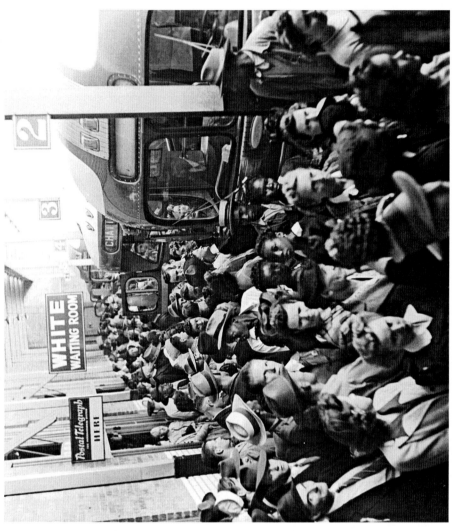

FIGURE 2.17 Esther Bubley, Memphis, Tennessee, September 1943. "People waiting for a bus at the Greyhound bus terminal"— under signs of segregation.

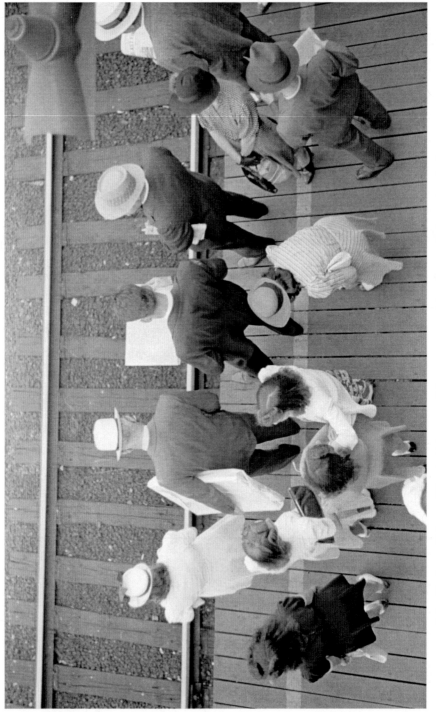

FIGURE 2.18 John Vachon, Chicago, Illinois, July 1941. "Commuters waiting for south-bound train."

FIGURE 2.19 Arthur Siegel, Detroit, Michigan, July 1942. "People lined up waiting for the 5 o'clock bus." The smile of one woman (toward the end of the line) stands out as an aberration amid the resignation on the faces of the others.

FIGURE 2.20 Photographer unknown [Ewing Galloway?], New York, New York, 1935? "Bread line beside the Brooklyn Bridge approach."

3

HIGH LIFE AND LOW LIFE

P eople moved around the city—by cars, buses, trolleys, and subways.
Often, this movement took them to work, but perhaps just as often it
took them out on the town, to partake of the "High Life and Low Life,"
as the American Guide Series volume on San Francisco described that city's
cultural atmosphere. At the end of the subway line in New York City lay Coney
Island, and the train ride to get there was a spectacle in itself, laying open the
city for view. People traveled to Atlantic City to experience that city solely as
amusement. Photographs throughout the FSA/OWI collection portray the
detail and the panache of "high life and low life," from the sophisticated offer-
ings of theaters and museums to the popular diversions of movies, dance halls,
and burlesques. The photographs also convey the stark contrasts between the
drudgery of work and the gaiety of leisure, the "low" of routinized, banal tasks
and the "high" of frivolity and ease. The city was on display, blemish and pol-
ish, along with the toil underlying both (Figures 3.1–3.3).

The variety of spectacles offered in cities spoke to the need for immersion
in the expressive, imaginative world of the arts. Movie houses abounded, add-
ing to the nighttime scene sparkling lights, decorative facades, and illuminated
signs blaring stars' names (Figures 3.4, 3.5). Movies pulled in diverse crowds,
from matrons with hats jauntily poised and sailors in Washington, D.C., to
African American children on the South Side of Chicago (Figures 3.6, 3.7).
The movies were only the most overt break from the despondency of the times.
Photographs of fashion and shopping—hat stores predominate—allude to
the wishing underlying much of the cultural fervor of the times. To imagine

oneself in a new hat or a new suit was to see a new role, another vision of the world in which one was composed, attractive, and capable—sure of where one was going (Figures 3.8, 3.9). People window shopped, if not to buy then at least to dream. A man is caught up in an empty lobby of a clothes store, imagining; his reflection in the window creates a new vision, as his mirrored head sits atop a mannequin displaying a dapper new suit (Figure 3.10).

One photograph, however, suggests how difficult that imagining might have been. A young African American woman stands in front of faded posters—most prominently a grinning clown face—on a worn building in Chicago. A young boy in her care, hazy at the bottom of the picture, smiles up at the posters, but the woman stares directly at the camera, her stoic expression making the clown's grin a mockery (Figure 3.11). The arts flourished in the Depression era because they presented a stark contrast to the long breadlines, deep poverty, and homelessness of the time. "High life" may have met the need for imaginative play and relief, but it was still inextricably linked to "low life," whether in the burlesque theaters or in the grinding challenges of survival.

If city life offered any solace in times of despair, it was in the variety of opportunities to communicate and to express oneself—and to evade desperation by turning to joyful abandonment and wishful escapism. The city as a center of communication comes across most in the abundant pictures of newspapers—the production, selling, and reading of them (Figure 3.12). The New York *Daily News* sold three million copies on Sunday alone; newsstands were permanent fixtures on city corners, a stopping point where residents could learn about those around them and those far away. The plentiful languages of the publications reveal the varied backgrounds of the city folk and their concern with world affairs, as demonstrated by an image of Chinese Americans in San Francisco peering anxiously over each other's shoulders to read news of Canton's surrender to the Japanese in 1938 (Figure 3.13). Such window reading contrasted with the furious activity of enterprising newsboys who commandeered the city streets, tussling over pennies, as this reminiscence from Chicago describes:

> When the streetcar was waiting for a red light to turn, we used to run up alongside the car and the people in the car would stick their hands through the windows for a paper. He'd stick his hand outside the window and maybe he'd have a nickel or a dime in it instead of the change. . . . If he gave us a nickel or a dime, it was just too bad. We'd fumble, we'd try and we'd fumble—boy; we sure had to dig deep for that change—and we'd run along beside the car when it started, but—

it never failed—we just couldn't reach him, the car would be picking up speed and we just couldn't reach his hand with that change. It never failed to happen. But I've had guys got [*sic*] off the car at the next stop and come back and make me give them their change. They were wised up, I guess, or maybe they'd sold papers once themselves. Anyway, I've had that happen to me.[1]

Newspapers served as a focus for conversation, and news offices as a gathering place, but the scrappy newsboys show another side of life in the city—reinforcing the poignancy of existing on the edge, of scratching out a living by connecting people to other people via newspaper sales. A lone newspaper seller in Memphis sits among his publications and possessions announcing faith in labor, God, and country, proclamations muted by his haunted gaze (Figure 3.14).

Photographs of newspaper stands, sellers, and offices merge with pictures of bookstores and libraries to demonstrate the central role of reading and conversation in cultural life. People of all ages gather in a bookstore in New York, stroll past magazine stands in Baltimore, and browse the bookstalls outside a store in New Orleans (Figure 3.15). A somber shot of unemployed men lining the concrete bench of the San Francisco Public Library reveals the gathering, conversational role of these institutions, perhaps not meeting their conventional purpose but a crucial one nonetheless (Figure 3.16). A window of the Workers Book Shop in New York City on 13th Street near Union Square broadcasts the politics of the moment—pushing for the opening of a "second front" in the world war to relieve pressure on the Soviet Union and its dramatically costly fighting—in a way that masks the identity of the store's owners and the building's other occupants: the headquarters of the Communist Party USA (Figure 3.17). The attention to Soviet concerns and the birthday wish for labor rights activist Mother Ella Reeve Bloor may be clearer indications of the bookshop's leanings, but the framing of the physical window—as well as the message of its contents—on a foundation of "danger" declared in the sign below seems to convey what is at stake. Perhaps most subtle is the reflection of the building on the opposite side of the street, Ohrbach's dress and coat shop mirrored backward, giving the glare of capitalism and materialism a ghostly but indelible presence in the window and in the movement.

The Workers Book Shop also makes clear that cities hosted a large workforce, one that included not only factory laborers but also those in cultural endeavors: entertainers were workers too. A passage from the San Francisco guide links cultural activities with the work life of the city:

As day merges into night, neon lights flash on. Cocktail lounges begin to fill; darkness brings a dinner rush. Musicians and entertainers, waitresses and night cooks scurry through alley entrances to the centers of the city's night life. Taxis move from hotel to night club, from restaurant to bar. Life becomes a rising tide, hidden behind frosted glass, pulsing to the blare of nickel phonographs or the fevered tunes of swing bands.

And then at two a.m. the lights go out; stools and tables are stacked; doors are closed. Musicians and dancers, kitchen help and customers, going home through dark and empty streets, hear the swish of street-cleaning trucks. The flare of an electric welder busy at a street intersection flashes through the night. Soon come the white milk trucks converging to their distribution points, and the mountainous garbage vans clattering from restaurant back doors loaded for suburban pig farms. Already stirring are the produce workers and fishermen whose work is about to begin.[2]

The work life of entertainers joined the twenty-four-hour rhythm of the city, adding a nighttime luster to the daily grind (Figures 3.18, 3.19). It also helped mark specific spots, even particular intersections:

"The Corner" was more than a mere loitering place. It was the Chicago gathering place of the vaudevillian; it was an open air club, a forum, an exchange, an information bureau—call it what you will, it never had a definite name. But the daily assemblies had a distinct professional information which was calculated to be of mutual benefit. Questions were constantly asked, and answered. Queries such as—"Who's booking the Orpheum in Hammond now?" "How many houses does Webster book?" "What's the fare to Evansville?" "Where can a fellow have some cheap lobby photos reproduced?" "Whatever became of The Six Damascos?" "What's the baggage hauling rates out to the Empress, at 63rd and Halsted?" "Is there a good hotel in Grand Rapids that makes professional rates?" "Can you get back to town from Rockford after the show Sunday night?"[3]

The owners of burlesque shops and nightclubs and the performers in those places were common urban dwellers, looking for work as well as a chance to express themselves. Whether loitering, picking up a gig, or sharing trade secrets, the cultural life of the city enhanced the random crossings and density of urban locales—and set reality against fantasy (Figure 3.20).

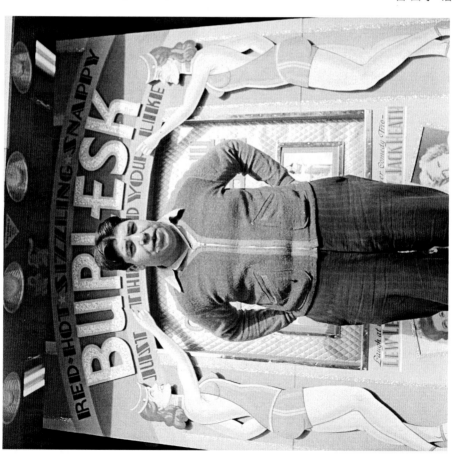

FIGURE 3.1 Marjory Collins, Baltimore, Maryland, April 1943. "Burlesque barker," luring crowds into the show.

FIGURE 3.2 Arthur Rothstein, Pittsburgh, Pennsylvania, July 1938. "Homemade swimming pool for steelworkers' children"—cooling off in the city whether by makeshift pool or by beer.

FIGURE 3.3 John Vachon, Chicago, Illinois, July 1941. "Ascending steps of El." Public transit served city dwellers on multiple levels, moving them through their workaday lives and offering an avenue of escape to diversions of all kinds.

FIGURE 3.4 Walker Evans, New Orleans, Louisiana, [1935 or 1936]. "The Liberty Theater on Saint Charles Street," featuring the spectacle of the movies. Advertising for Morton's Salt adds to the visual landscape of consumer fantasies.

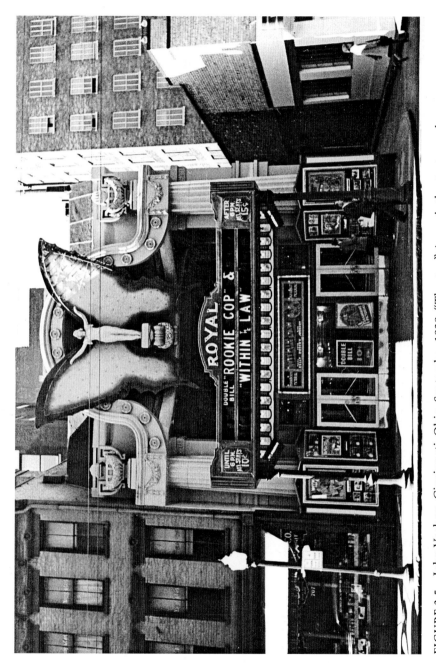

FIGURE 3.5 John Vachon, Cincinnati, Ohio, September 1939. "Theater." A movie theater topped with butterfly wings shadowing a maiden adds some dazzle to an otherwise humdrum street.

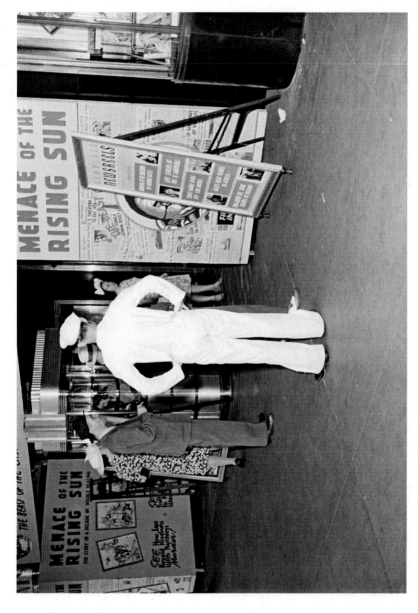

FIGURE 3.6 John Ferrell, Washington, D.C., July 1942. "Sailor looking at posters in front of the Trans Lux Theatre." *Menace of the Rising Sun* supplied blatant anti-Japanese propaganda common in the war effort.

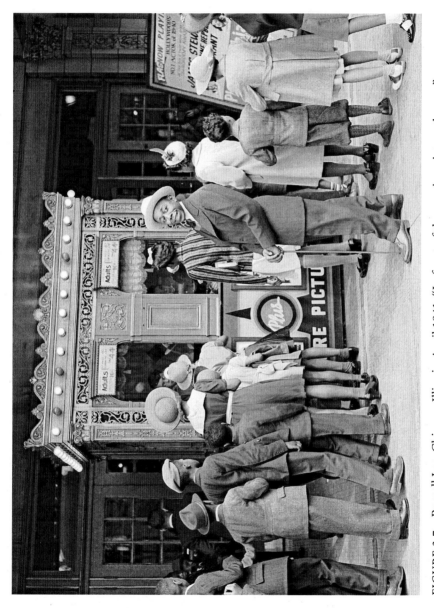

FIGURE 3.7 Russell Lee, Chicago, Illinois, April 1941. "In front of the moving picture theater." Going to see the big hit *Philadelphia Story* inspires dressing up in finery.

FIGURE 3.9 John Vachon, Chicago, Illinois, July 1941. "Waiting for a street car." The intersection of hats in the city, Part Two.

FIGURE 3.8 Gordon Parks, Washington, D.C., August 1942. "Display window at 7th Street and Florida Avenue, N.W." The intersection of hats in the city, Part One.

FIGURE 3.10 John Vachon, Chicago, Illinois, July 1941. "Window shopping." The photograph reveals the new, imagined self through the reflection in the window.

FIGURE 3.11 Edwin Rosskam, Chicago, Illinois, April 1941. "Circus posters, Black Belt."

FIGURE 3.12 Marjory Collins, New York, New York, January 1943. "Newsstand on Fourth Avenue at Fourteenth Street which sells foreign language newspapers." News in many languages vies with horoscopes, sports, and romance.

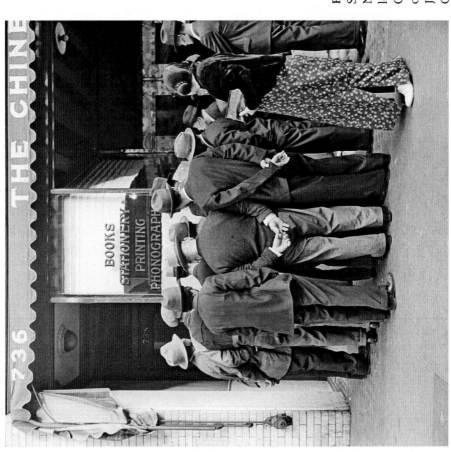

FIGURE 3.13 Dorothea Lange, San Francisco, California, November 1938. "Front of the local paper of San Francisco's Chinatown Chinese read news of the surrender of Canton to the Japanese. Most of San Francisco's Chinese are Cantonese."

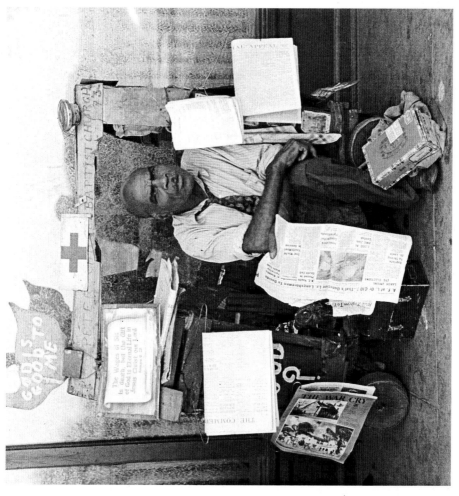

FIGURE 3.14 Russell Lee, Memphis, Tennessee, September 1938. "Newsstand." A newspaper seller proclaims his faith, in labor, God, and country.

FIGURE 3.16 Dorothea Lange, San Francisco, California, February 1937. "Unemployed men sitting on the sunny side of the San Francisco Public Library," where they find conversation if not books.

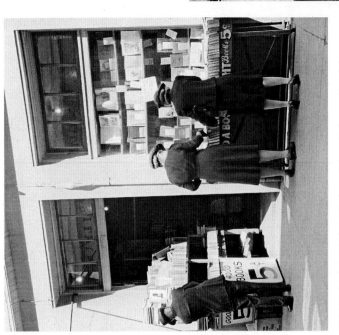

FIGURE 3.15 John Vachon, New Orleans, Louisiana, March 1943. "Book shop."

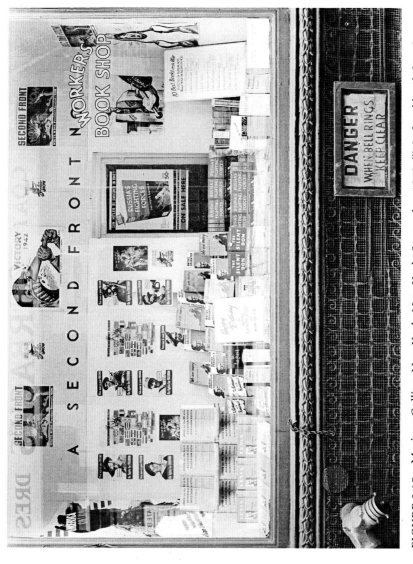

FIGURE 3.17 Marjory Collins, New York, New York, September 1942. "Workers' bookshop in a building on 13th Street between University Place and Broadway, which is the headquarters of the Communist party. No mention of Communism appears in the display or on the building."

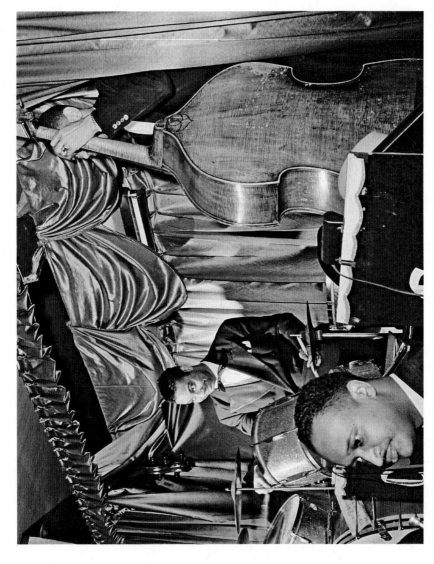

FIGURE 3.18 Jack Delano, Chicago, Illinois, April 1942. "Oliver Coleman playing in a nightclub on 55th Street."

FIGURE 3.19 Russell Lee, Chicago, Illinois, April 1941. "Negro cabaret." A cabaret flaunts the contours of racism, as white patrons watch African Americans' vaunted sexuality and hear their musical prowess.

FIGURE 3.20 John Vachon, Cincinnati, Ohio, October 1938. "Girl and movie poster." Fantasy envelops her.

4

The City in the Country

~

Lists of amusements were common in city volumes of the American Guide Series, but even guides to more rural states noted the influence of "culture, in the urban sense," as South Dakota's guidebook put it, in the rise of libraries, literary societies, touring dramas, art exhibits, and lectures.[1] Boys peer into a nickelodeon at a South Louisiana State Fair seeking the allure of sex and the variety of enticements the big city offers (Figure 4.1). Photographs display the increasing presence of the city in the countryside, revealing the flow of images, goods, ideas, and habits between these two areas. Cars and their excess—signs, traffic lights, paved roads, auto shops, and junkyards—began to dominate the rural areas as they did the urban ones (Figures 4.2, 4.3). And the exchange went both ways. As a 1937 government report indicated, links increased between more and less settled areas: country ways found their place in cities, and city goods and habits became part of country life. Moving to the city inevitably meant bringing customs and practices from the country.[2]

Once in the city, country folks were visible in horse-drawn wagons full of goods, most for sale. While farm produce was commonly for sale on city streets, agricultural fields also appeared on the outskirts of cities such as New York, a transplantation of rural traditions and a means for sustainability, especially during the war, when "victory gardens" inspired by Eleanor Roosevelt's so-named garden at the White House sprang up (Figure 4.4). The occasional wagon or cart found its way onto city streets for nonagricultural purposes

as well—as means of transporting personal possessions for those without cars (Figures 4.5, 4.6).

Movement between rural and urban areas resulted in highways that dominated maps and highlighted the growing centrifugal force of cities. A map of Texas in the late 1930s displayed the fact that the state government spent more money on highways during this era than on any other kind of transportation, producing lines running across the state; in 1939, Texas spent $48,211,350 on highways alone.[3] The crossings of the map also demonstrated the magnetism of the dominant city of the state, Dallas, with all roads leading to it, like arteries to a heart. While cities may have been the centers of activity, the surrounding areas became all the more accessible and prized in an era of car travel. "The automobile made it possible for more and more citizens to move away from the older, crowded, somewhat rundown sections of the city to the cleaner, quieter neighborhoods in the hills," the Cincinnati guide proclaimed. "New highways and viaducts helped shatter the isolation of the onetime self-sufficient suburbs, and autobus vehicles enabled commuters to work in the city and live near the country."[4] Along with the highways came large signs throughout the countryside that pointed the way to the city. Small bus and train depots dotted wide plains, as temporary way stations on a certain path to the city (Figure 4.7)

As mobility expanded, city dwellers increasingly sought temporary refuge in the countryside. Cars jammed highways leading out of the cities as weekends or holiday periods began; bus depots and gas stations marked the main highways, alongside junkyards of old car parts; and "tourist courts"— inexpensive motels for car travelers—appeared in the south and west, shifting the economic bases of those areas toward ones geared to servicing the visitors in cars (Figures 4.8–4.10). The Florida guide describes the transformation:

> The pioneer settler [of Florida] . . . knew little of life beyond his own small clearing and saw only a few infrequent visitors, until a network of highways left him exposed to many persons in motorcars. This traffic affected his economy and aroused his instinct to profit. He set up a roadside vegetable display, then installed gasoline pumps and a barbecue stand, and finally with the addition of overnight cabins he was in the tourist business.[5]

Commodities followed this movement of people, and national brands overwhelmed local ones as people bought what was familiar regardless of where they were. The ubiquity of Coca-Cola—on signs and in bottles—reflected the growing dominance of national products (Figure 4.11). In concert with the

products, advertising even began to serve as decoration at times, as illustrated in a beer garden and store in Interlochen, Michigan (Figure 4.12). These goods and images provided a sense of familiarity to travelers and summertime residents, who may have been eager to spend some time in the woods but wanted to retain the comforts of home.

Interlochen not only offered an escape from the city along with a range of comfortable products in its stores, but it was also the summer home of a camp for musicians studying classical music (Figure 4.13). Rural states such as Maine, which had little urban life of its own, became popular summer homes for city residents who filled summer stage theaters and artists' colonies. Theaters appeared in rural areas that were otherwise noteworthy for their isolation— on a dirt road or in a building thoroughly unlike the surroundings on the main street of a town—with marquees that advertised the showing of movies produced out of Hollywood (Figure 4.14). And the spread of urban life went beyond the summertime visitors, as the radio became the centerpiece in most homes, beaming in news from around the country, along with comedy shows, horror tales, and opera. A wall hanging above the radio in a family home highlights the change, from piano as focal point to radio as the center of attention (Figure 4.15). Traveling spectacles arrived in small towns, and entertainers moved from bigger cities to smaller ones—entertainers such as the saloon singer Mildred Irwin, who settled in North Platte, Nebraska, after having lived in Omaha for almost twenty years (Figure 4.16).[6]

Community literary and theatrical groups grew up alongside the more ribald entertainment and took on an increasingly central role in town life (Figure 4.17). "There was very little in the way of entertainment and so the literary society was an event of importance," remembered Sarah Hartje of Roca, Nebraska.[7] "Texas lost its frontier character in the march of people to the cities," proclaimed its state guide. "And, with the conquest of the wilderness accomplished, the people turned now to higher education, to the development of Texas literature, music, theater, and art movements."[8] This "serious effort to acquire culture," according to the South Dakota guide, resulted in a wave of activity throughout the state, from small town to big city: "Farm families meet weekly in rural schools to discuss new books furnished by the State's free lending library; villages have active literary societies and imported lecturers; people in cities turn out en masse to band and orchestral concerts, to local and roadshow dramas, operas and art exhibits. In nearly every town are libraries and historical museums, in which are proudly exhibited collections of Indian relics and those of pioneer days."[9] The cultural influence of urban centers went beyond particular exhibitions or performances, too, and began to

change customs. The "urban tendency to break up into small groups," according to the Texas guide, meant people were moving from the church as the social centerpiece to private clubs with activities based on recreation, hobbies, and other leisure interests.[10]

Photographs that display the view of city life from the country most dramatically indicate the turn of aspirations to the city. Two African American boys stand on a hillock above the new Frederick Douglass housing project in the Anacostia section of Washington, D.C., projecting the city as the hazy but ineluctable future (Figure 4.18). Other photographs show the development of the in-between state of suburbia in most parts of the country: housing developments appear in the middle of untended land with a city skyline in the distance. Even the pictures of the slums that outlined major cities convey the magnetism of the fuzzy skyscrapers in the background. A poor neighborhood outside of downtown Detroit hosts bare streets, trees devoid of leaves, and worn wooden houses in the wake of residents moving to the new Sojourner Truth housing development further out of the city (Figure 4.19). Even though movement to such housing developments and the suburbs would soon escalate, after the end of World War II, the photographs impart the bond to and allure of the urban core (Figure 4.20).

FIGURE 4.1 Russell Lee, Donaldsonville, Louisiana, October 1938. "Boys looking at penny movies at South Louisiana State Fair," choosing sexual allure over comedy.

FIGURE 4.3 Jack Delano, Childersburg, Alabama, May 1941. "Newly painted parking signs prepared in anticipation of an increase in traffic."

FIGURE 4.2 Russell Lee, Taylor, Texas, October 1939. "Painting traffic lights."

FIGURE 4.4 Howard R. Hollem, New York, New York, June 1944. "Victory gardening at Forest Hills, Queens."

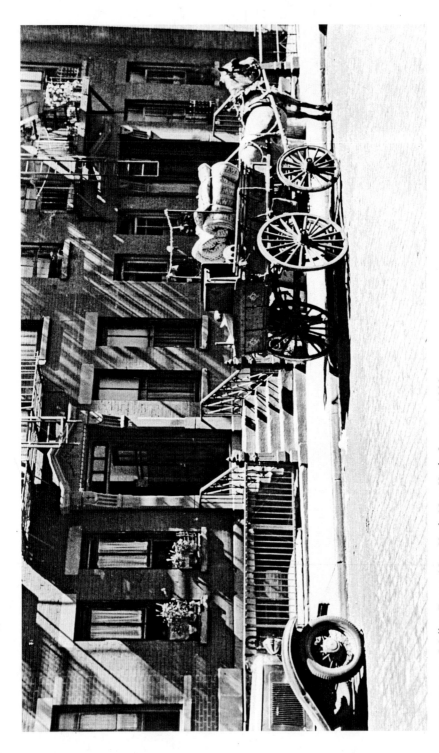

FIGURE 4.5 Walker Evans, New York, New York, Summer 1938. "61st Street between 1st and 3rd Avenues. A tenant is moving."

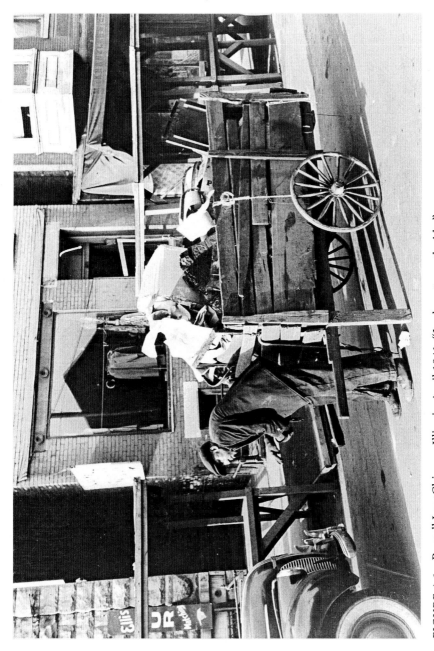

FIGURE 4.6 Russell Lee, Chicago, Illinois, April 1941. "Junk cart, south side." A man carries his possessions without the help of a horse.

FIGURE 4.7 Russell Lee, New Madrid, Missouri, May 1938. "Halfway bus station between Memphis and St. Louis."

FIGURE 4.8 Marion Post Wolcott, New York, New York, May–June 1941. "Traffic on a highway from New York City to the shore on Sunday."

FIGURE 4.10 Russell Lee, outside Phoenix, Arizona, February 1942. "Lineup of tourist courts."

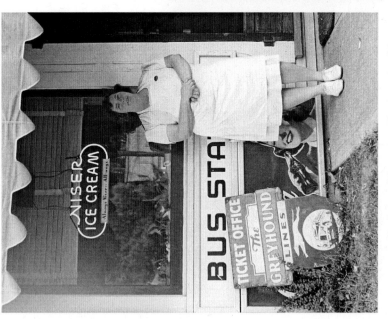

FIGURE 4.9 Esther Bubley, near Cincinnati, Ohio, September 1943. "The ticket agent at a small town station," serving ice cream as well as a chance to leave town.

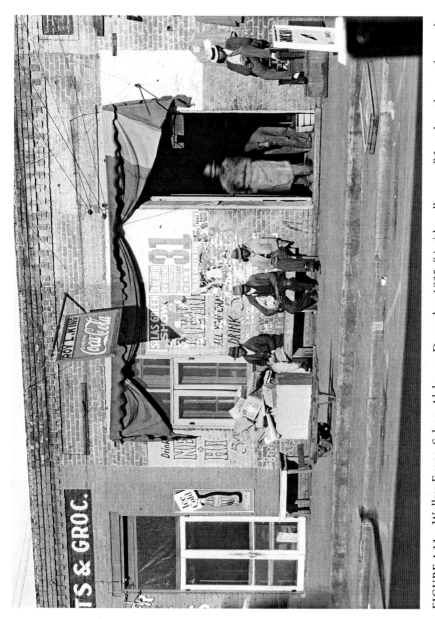

FIGURE 4.11 Walker Evans, Selma, Alabama, December 1935. "A sidewalk scene." Locals gather underneath a Coca-Cola sign and an advertisement for an African American circus-variety show.

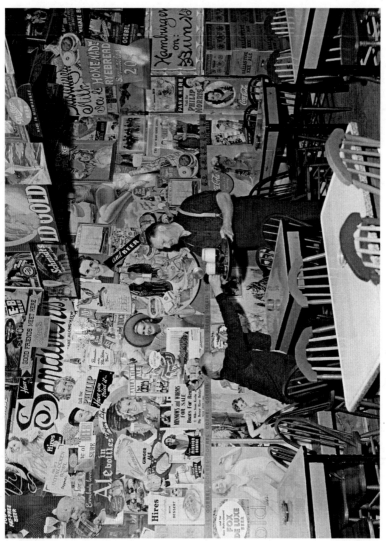

FIGURE 4.12 Arthur Siegel, Interlochen, Michigan, August? 1942. "National music camp where 300 or more musicians study symphonic music for eight weeks each summer. Beer garden near camp is completely covered with beer and cigarette advertising signs," most of them trading on the allure of women.

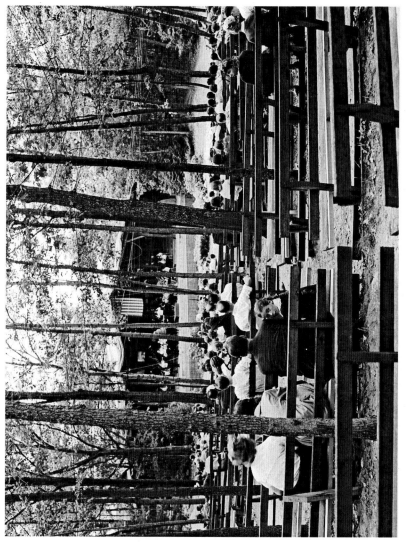

FIGURE 4.13 Arthur Siegel, Interlochen, Michigan, August? 1942. "National music camp. . . . Looking through the trees at orchestra practicing." A young girl seems to be less entertained by the music emerging from beneath a U.S. flag than by the photographer capturing the scene.

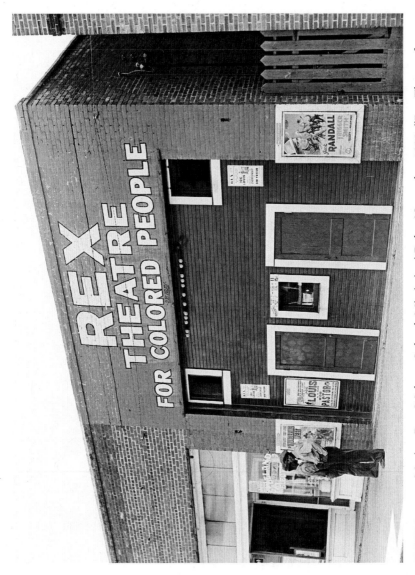

FIGURE 4.14 Marion Post Wolcott, Leland, Mississippi Delta, November 1939. "Rex Theatre for colored people," presenting the latest Hollywood western featuring Jack Randall, a cowboy star of the 1930s and '40s.

FIGURE 4.15 Russell Lee, Hidalgo County, Texas, February 1939. "Tenant purchase clients at home." A government-subsidized program allowed farmers to buy back farms on favorable terms (which these people clearly needed if the gaping hole in the man's sock is any indication of their means). The radio served as a kind of hearth—a place of honor and focus for pictures of grown-up children.

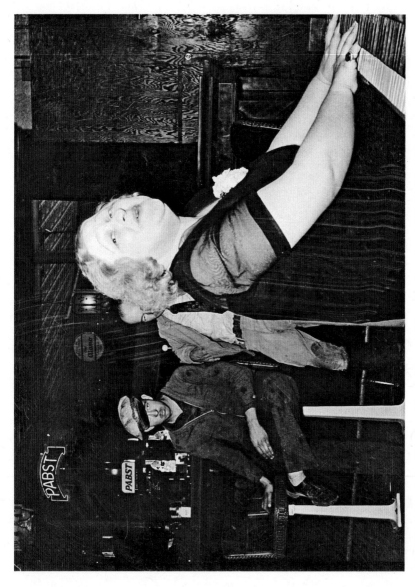

FIGURE 4.16 John Vachon, North Platte, Nebraska, October 1938. "Mildred Irwin, entertainer in saloon at North Platte, Nebraska. She entertained for twenty years in Omaha before coming to North Platte."

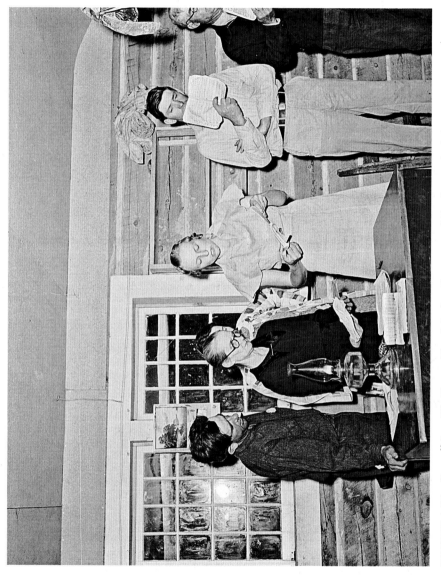

FIGURE 4.17 Russell Lee, Pie Town, New Mexico, June 1940. "Singing at the literary society meeting."

FIGURE 4.18 Gordon Parks, Anacostia, D.C., June 1942. "Frederick Douglass housing project. Boys overlooking the project," as if looking to the future. The halo effect of the framing gives the pose an allegorical edge.

FIGURE 4.19 Arthur Siegel, Detroit, Michigan, February 1942. "Looking towards downtown from the slum area in the early morning. These are conditions under which families originally lived before moving to the Sojourner Truth housing project."

FIGURE 4.20 John Vachon, Jefferson County, Kansas, October 1938. "Farm for sale."

5

CITIZENS

~

A mong the aspirations linked to urban life, perhaps none was more captivating than the opportunity for full participation and citizenship. Immigrants from around the world as well as migrants from rural areas, especially African Americans, came to the cities of the United States drawn by this promise (Figure 5.1). A cigar maker originally from Spain shows his yellowed, creased citizenship paper to an interviewer—then carefully refolds it and places it back in a safe.[1] Cities provided a chance to work toward citizenship and ample evidence of democracy in action, and immigrants added to the increasingly cosmopolitan nature of urban life. Chinese families shopped for medicinal herbs next to Italians curing meat; Norwegians paraded in honor of their heritage. "The city is a cluster of ethnic groups," the New York City guide declared. "Definite foreign colonies exist, but the lines are constantly shifting . . . [and] much that has come to be considered peculiarly American is the direct contribution of these latter-day citizens."[2] Photographs depicting the polyglot character of urban life increased during the war years, as the project was transferred from the FSA to the OWI and cities became the more common setting for government photographers—precisely because of the need to propagandize the American way of democracy at the time of a burgeoning world war. From celebrating cultural roots to demanding workers' rights, city residents could take action on contemporary issues and connect to the world beyond the nation.

During the era of the Great Depression people became more passionate about politics, and the country leaned further toward socialism and communism than at any other point in the nation's history (Figure 5.2). The economic plight of many prompted a call for change—a revolution that arose in the streets and factories across the country—a demand for recognition of the dire economic conditions and an insistence upon more government support. Stryker directed FSA photographers to stay out of the political arena—seeing the mission of the project as far beyond the political contingencies of the moment—but photographers occasionally caught the action nonetheless. Strikes occurred in Chicago as United Office and Professional Workers protested poor pay and demanded union recognition (Figure 5.3); workers in the New Deal agencies of the Works Progress Administration coordinated nationwide protests in February 1939 to denounce dramatic cuts in appropriations (Figure 5.4); people signed petitions to decry the forced relocation of migrants into labor camps (Figure 5.5); and a "South Side Action Committee" sign in the Bronzeville neighborhood of Chicago, appearing in a kind of bubble on a window, conveyed the ubiquity of action and community that was commonplace in numerous organizations trying to stem the calamitous times (Figure 5.6). As war began, political deeds took on more specific aims to support the effort—for example, buying war bonds or donating "typewriters for victory" from Hollywood studios to the armed services (Figures 5.7, 5.8).

Perhaps the most significant and striking action pictured is the fight of African Americans for full inclusion in U.S. society. The quiet dignity and effort of this struggle comes across most poignantly in photographs of African Americans in government roles—predominantly as police officers and members of the military (Figures 5.9–5.11). Such images stand in contrast to a series of pictures documenting a 1942 riot in the federally subsidized Sojourner Truth housing project in Detroit (Figures 5.12, 5.13). The housing project had caused consternation from its beginning—when it was first announced that the development would be for African American families in response to the growing housing crisis in the area created by the influx of African American workers to the defense industry. The surrounding white community raised enough outrage that the decision regarding residence preferences was reversed, then reversed again, conferring final designation as being a project for African Americans. Occurring at the time the first families moved in, the riot exposed the blatant racism that still segregated both social and spatial relations. Signs declared "We want white tenants in our white community." These protests presaged the far more devastating ones that would rock Detroit the following year and would set the battle lines for the civil rights movement of the years to come.

The photographs of racial neutrality, if not reconciliation, are that much more striking in comparison with the images of discord. John Vachon captured just such an instance during an Armistice Day parade in Omaha in 1938 (Figure 5.14). The staunch, upward tilt of the chin of the African American man looking firmly ahead—poised against the waving flag and a white man standing over him—reflects the solid determination that kept many steady in the fight for civil rights. The white man at the right of the frame, nearly swept over by the flag, staring directly at the camera, could be looking to us—to the future—with knowing eyes about the inevitable racial conflicts yet to come. Vachon's gaze in this photo may have been influenced by a conversation that he had had a couple of weeks earlier in Cincinnati that he described to his wife as evidence of the open racism he encountered there. A man driving him around uttered "very nasty things about" African Americans, noting their presence as "the only thing he has against the city."[3]

The parades pictured throughout the FSA/OWI collection give a reconciliatory view of the nation, as one might expect, coming together beyond differences in celebration of a more unitary vision. But within that patriotic haze, they also reveal the intricate assembly of people living side by side in cities around the country. Events such as the parade celebrating Cincinnati's one hundred fiftieth birthday or a celebration in New York's Little Italy supporting neighborhood boys fighting in the war provided moments to transcend divisiveness, literally to stand next to one another, attending to a vision of greater unity (Figures 5.15, 5.16). Similarly, Katherine, a Polish immigrant, gained citizenship not only to vote but also to participate in the Polish-American Citizens Club, which hosted dances and parades. "This is freedom, this America, everybody glad!" she exclaimed.[4]

Parades in the city encouraged the random connection to others characteristic of urban life and—by bringing together diverse audiences—served to extend the sense of connectedness to encompass other peoples around the world. The World's Fair of 1939–1940 in New York City cemented the emerging role of American cities in the world, replete with futuristic urban visions and all they would offer. More mundane than that grand event, international flags adorned Union Station in Chicago, and an exhibition lining the ice-skating rink at Rockefeller Center educated visitors about different nations around the world, putting those nations at the center of the city and in the paths of both tourists and New Yorkers (Figures 5.17, 5.18). A few years before the formation of the United Nations, Washington, D.C., hosted an international student assembly, bringing youth from across the globe to that city to learn from one another and to imagine new relations in the world (Figure 5.19).

And San Francisco hosted the conference that formed the United Nations in 1945, which prompted the guidebook for the city to claim that "the citizen of San Francisco is a citizen of the world."[5] Striking a more ambivalent stance, in the *Middletown* of transition, one "becomes a citizen of a wider world as a larger city tends to develop a more metropolitan emphasis in its press, as its stores become more sensitive to the 'latest New York styles,' and as better-known speakers can be imported for civic clubs."[6]

The view from the FSA/OWI collection reinforces the centralizing force of urbanization and the emergence of ever more powerful large urban areas. Despite the occasional conflict, incomplete promises of citizenship, or hard edges of urban life, the photographs present a primarily halcyon view (Figure 5.20). If these photographs have a celebratory, assimilationist tinge—more often allowing strangers to mix with little strife or perhaps full inclusion—they also presented the random intersection and strangeness inherent in urban life as an allure rather than a threat. Urbanism, if not residence in a city itself, became the common way of life, something less specific to one place and more a new condition of living, as the guide to Baltimore declared:

> It is not Baltimore streets, Baltimore architecture, Baltimore monuments, Baltimore factories that eventually charm the newcomer and make him wish to spend here the remainder of his days. Rather it is the essence of lusty, cantankerous life that this sprawling city distills, under the placid surface of its neo-British aristocracy, which causes people from Kalamazoo and Mauch Chunk and Yazoo City and Walla Walla to label themselves, sooner or later, Baltimoreans.[7]

The "lusty, cantankerous life" lured many who needed to believe that things would get better in those desperate times. Americans marching to the city looked not only from plains to towns to ever larger metropolitan regions for that hope but began to encompass the world in their view and claim a central place for the United States in it. And it was the country's cities that would provide both the engine and the dwelling of that power.

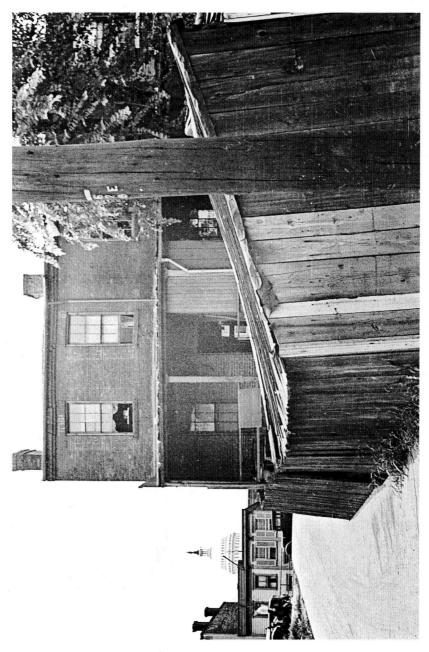

FIGURE 5.1 Carl Mydans, Washington, D.C., September 1935. "This section houses a crowded Negro population living in most unsanitary conditions" —all in view of the U.S. Capitol.

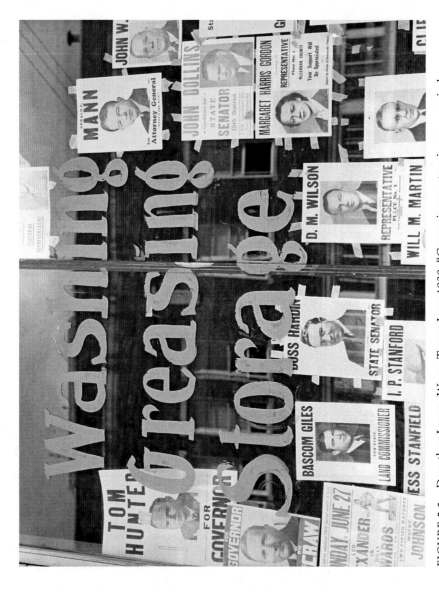

FIGURE 5.2 Dorothea Lange, Waco, Texas, June 1938. "Campaign posters in garage window, just before the primary."

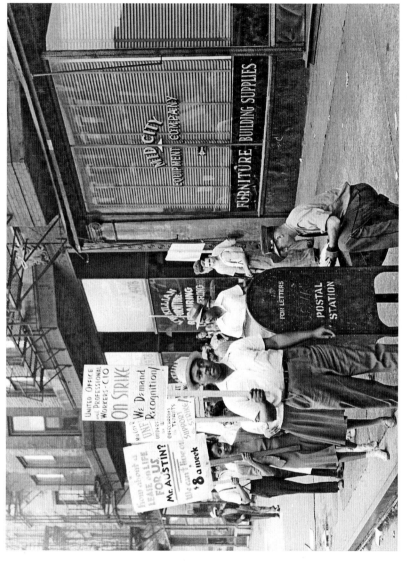

FIGURE 5.3 John Vachon, South Chicago, Illinois, July 1941. "Picket line in front of Mid-City [Equipment] Company." A federal minimum wage had been set at $0.25/hour in 1938, which suggests that these workers had ample reason to seek higher pay.

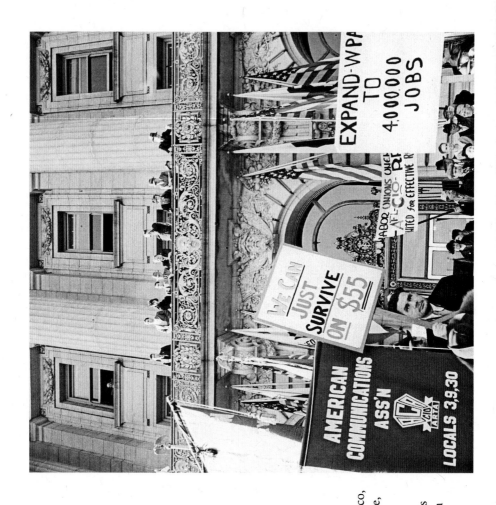

FIGURE 5.4
Dorothea Lange, San Francisco,
California, February 1939.
"In front of city hall, San Francisco,
California. The Worker's Alliance,
Works Progress Administration
(WPA) organize simultaneous
demonstrations in the large cities
of the nation [against the] cut in
the relief appropriation by the
United States Congress."

FIGURE 5.6 Russell Lee, Chicago, Illinois, April 1941. "Sign in Negro section." Action seems to emerge from multiple layers and overlapping images.

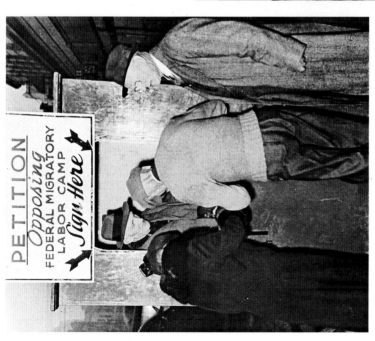

FIGURE 5.5 Photographer unknown, Portland, Oregon, 1939. "Opposition to government migratory labor camps." Government labor camps sprouted in the western states to provide basic sustenance to migrants, but they also compounded the losses of migration and poverty.

FIGURE 5.7 Roger Smith, New York, New York, June 1943. "Street scene on 52nd Street." Political action begins to turn toward the war effort, encouraging contributions today so as to "bomb Tokio [*sic*] tomorrow."

FIGURE 5.8 Photographer unknown, Los Angeles, California, July–November 1942. "Hollywood enlists its typewriters for war. Hollywood studios have answered the nation's call for typewriters for the armed services. Picture shows a load of machines released by 20th Century Fox studies to two [of] Uncle Sam's WAVES [Women Accepted for Volunteer Emergency Services]. The schools and private owners to sell one out of every four machines to obtain 600,000 typewriters."

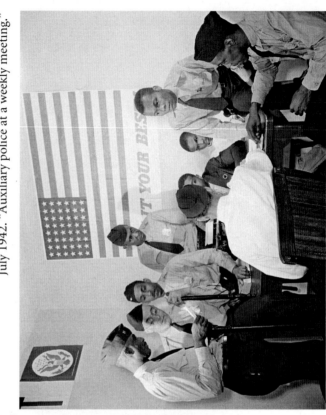

FIGURE 5.10 Gordon Parks, Washington, D.C., July 1942. "Auxiliary police at a weekly meeting."

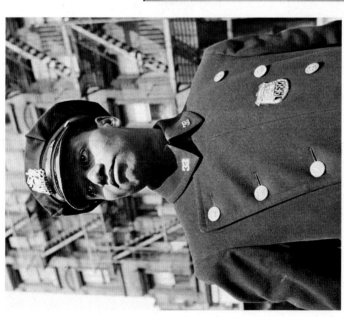

FIGURE 5.9 Gordon Parks, New York, New York, May 1943. "Policeman no. 19687."

FIGURE 5.11 Roger Smith, Harlem, New York, June 1943. "Street scene in Harlem."

FIGURE 5.12 Arthur Siegel, Detroit, Michigan, February 1942. "Typical Negro family at the Sojourner Truth homes."

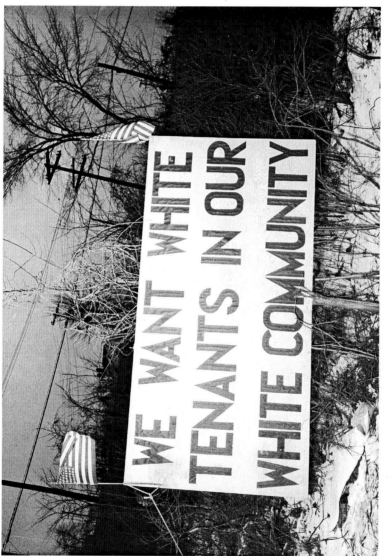

FIGURE 5.13 Arthur Siegel, Detroit, Michigan, February 1942. "Riot at the Sojourner Truth homes, a new U.S. federal housing project, caused by white neighbors' attempt to prevent Negro tenants from moving in. Sign with American flag[s]: 'We want white tenants in our white community,' directly opposite the housing project."

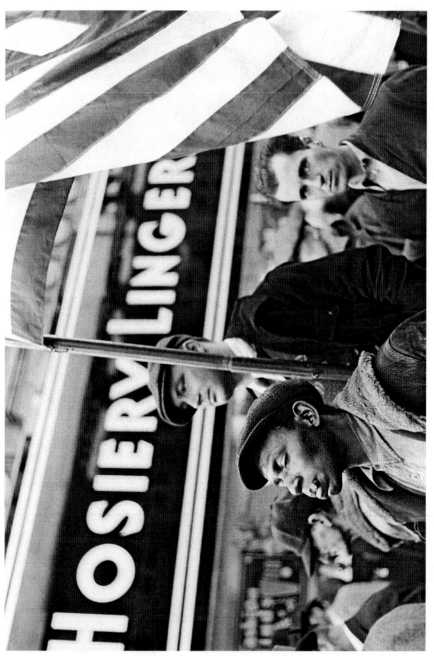

FIGURE 5.14 John Vachon, Omaha, Nebraska, November 1938. "Watching Armistice Day parade."

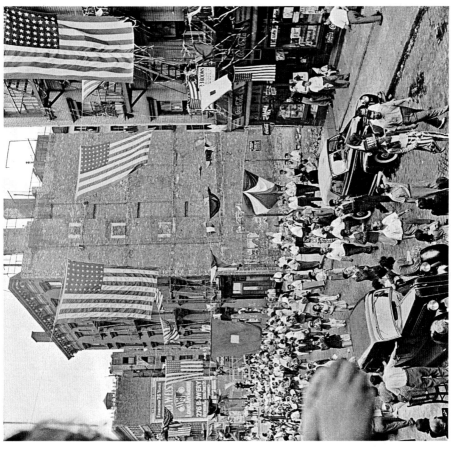

FIGURE 5.15 Marjory Collins, New York, New York, August? 1942. "Parade of Italian-Americans on Mott Street at a flag raising ceremony in honor of neighborhood boys in the United States Army." A person leans out a window on the left to watch "Uncle Sam" lead.

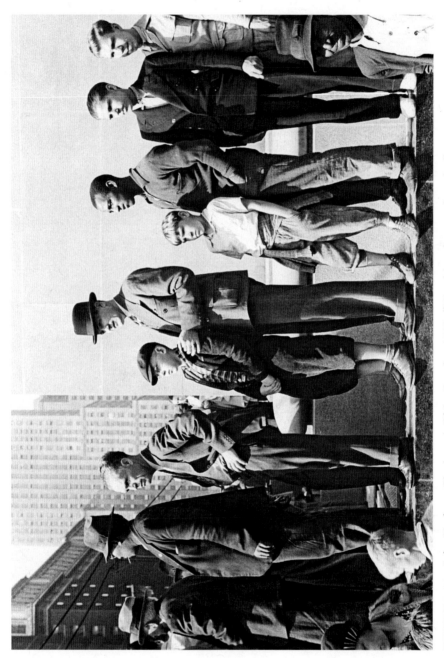

FIGURE 5.16 John Vachon, Cincinnati, Ohio, October 1938. "Watching the parade go by."

FIGURE 5.17
Jack Delano, Chicago,
Illinois, January 1943.
"Union Station
concourse."

FIGURE 5.18
Marjory Collins, New York, New York, March 1943. "United Nations exhibition of photographs presented by the United States Office of War Information (OWI) on Rockefeller Plaza. Posters of all nations were mounted on colored boards around the edge of the skating rink."

FIGURE 5.19 Gordon Parks, Washington, D.C., September 1942. "International student assembly. Indian delegates, left to right: Miss Sita Guha Thakurta; K. Z. Fournadjiadieff, a student at Yale University; Miss Satiavati E. Cotelingan, a student at the Biblical Seminary; Miss Kamala Kosambi, a student at the University of Michigan."

FIGURE 5.20 John Vachon, Pittsburgh, Pennsylvania, June 1941. "Flag Day"—in the city.

NOTES

INTRODUCTION

1. The photography of the 1930s, both in the Farm Security Administration collection and beyond it, has received a great deal of attention. For good overviews of the FSA/OWI, see Roy Emerson Stryker and Nancy Wood, *In This Proud Land: America 1935–43 as Seen in the FSA Photographs* (New York: Graphic Society, 1973); Jack Hurley, *Portrait of a Decade: Roy Stryker and the Development of Documentary Photography in the Thirties* (Baton Rouge: Louisiana State University Press, 1972); *Documenting America, 1935–43* (Berkeley: University of California Press, 1988), edited by Carl Fleischhauer and Beverly W. Brannan; James Curtis, *Mind's Eye, Mind's Truth: FSA Photography Reconsidered* (Philadelphia: Temple University Press, 1989); Nicholas Natanson, *The Black Image in the New Deal: The Politics of FSA Photography* (Knoxville: University of Tennessee Press, 1992); and Cara A. Finnegan, *Picturing Poverty: Print Culture and FSA Photographs* (Washington, DC: Smithsonian Books, 2003). Other studies put the FSA in broader contexts: Maren Stange, *Symbols of Ideal Life: Social Documentary Photography in America, 1890–1950* (New York: Cambridge University Press, 1989); James Guimond, *American Photography and the American Dream* (Chapel Hill: University of North Carolina Press, 1991); Miles Orvell, ed., *John Vachon's America: Photographs and Letters from the Depression to World War II* (Berkeley: University of California Press, 2003); and John Raeburn, *A Staggering Revolution: A Cultural History of 30s Photography* (Chicago: University of Illinois Press, 2006).

2. "Standards of the Documentary File" [1937?], reprinted in Orvell, *John Vachon's America,* 282–285; quote 282.

3. Peter Bacon Hales, *Silver Cities: Photographing American Urbanization, 1839–1939* (Albuquerque: University of New Mexico, revised and expanded, 2005 [original

1984]), presents a provocative and convincing assertion that photography grew up in and because of urbanization. He sees photography eclipsed by movies by the 1930s and mass culture holding together visions of the city as photography did in an earlier period. Books of photography that feature urbanization directly generally focus on one city or one photographer, such as *New York Changing: Revisiting Berenice Abbott's New York* (Princeton, NJ: Princeton Architectural Press, 2004), which poses the photographs of Berenice Abbott alongside contemporary photographs of the same place; a re-issue of Walker Evans's *Many Are Called* (New Haven, CT: Yale University Press, 2004 [original 1966]) provides a unique slice of New York life through surreptitious photographs taken on the subway in the late 1930s. Maren Stange's study of Chicago, *Bronzeville: Black Chicago in Pictures, 1941–43* (New York: The New Press, 2002), combines well-selected photographs along with original text by Richard Wright and commentary by Stange.

4. "The Farm Security Photographer Covers the American Small Town," reprinted in Orvell, *John Vachon's America,* 291.

5. Robert Lynd and Helen Lynd, *Middletown: A Study in American Culture* (New York: Harcourt Brace, 1929); "Sample Items from a Small Town Shooting Script," reprinted in Orvell, *John Vachon's America,* 291–293; quote 292. See also the description of the encounter between Lynd and Stryker and emergence of the small town focus in Hurley, *Portrait of a Decade,* 96–100.

6. Robert Lynd and Helen Lynd, *Middletown in Transition: A Study in Cultural Conflicts* (New York: Harcourt Brace, 1937). For an overview of the two studies, see Rita Caccamo De Luca, *Back to Middletown: Three Generations of Sociological Reflections* (Palo Alto, CA: Stanford University Press, 2000).

7. Michael Johns, in *Moment of Grace: The American City in the 1950s* (Berkeley: University of California Press, 2003), argues that the heyday occurred in the 1950s, but both the statistical determinants as well as the more effable cultural ones suggest that the "moment of grace" occurred before then; the turn to the suburbs was well under way by the 1950s. Kenneth Jackson, *Crabgrass Frontier: The Suburbanization of the United States* (New York: Oxford University Press, 1985), is the standard account that develops a considerably longer timeline of the suburbs.

8. *Our Cities: Their Role in the National Economy* (Washington, DC: Report of the Urbanism Committee to the National Resources Committee, 1937), vii.

9. Ibid.

10. Ibid., vi.

11. Louis Wirth, "Urbanism as a Way of Life," *American Journal of Sociology* 44, no. 1 (1938): 1–24; Lewis Mumford, "What Is a City?" *Architectural Record* 82 (1937): 58–62, which formed the kernel of his *The Culture of Cities* (New York: Harcourt Brace, 1938). For a perceptive analysis of Wirth's impact on urban history, see Zane Miller, "Pluralism, Chicago School Style: Louis Wirth, the Ghetto, the City, and 'Integration,'" *Journal of Urban History* 18, no. 3 (1992): 251–279, especially 264–266 on the essay "Urbanism as a Way of Life." On visuality, see Hales, *Silver Cities,* and Frederic Stout, "Visions of a New Reality: The City and the Emergence of Modern

Visual Culture," in *The City Reader*, 2nd ed., eds. Richard T. LeGates and Frederic Stout (New York: Routledge, 2000 [original 1996]), 143–146.

12. Arthur Rothstein, *Arthur Rothstein: Words and Pictures* (New York: American Photographic Book Publishing, 1979), 7.

13. Dorothea Lange quoted in *Dorothea Lange*, in an essay by Christopher Cox (New York: Aperture, 1987), 8.

14. Ibid., 114. Lange specifically notes the dramatic transformation wrought in her lifetime, "that little space," from rural to urban.

15. Hales, *Silver Cities*, recognizes that the FSA photographs see the "the city to be the locus where the fundamental decision could be made, the works of art produced, the goods and services manufactured, distributed, and consumed" (467).

16. *Just Before the War: Urban America from 1935 to 1941 as Seen by Photographers of the Farm Security Administration* [exhibition catalog], with an introduction by Thomas H. Garver, and prefatory notes by Arthur Rothstein, John Vachon, and Roy Stryker (New York: October House, 1968), 7.

17. For more on the American Guide Series, see two anthologies: Bernard A. Weisberger, ed., *The WPA Guide to America: The Best of 1930s America as Seen by the Federal Writers' Project* (New York: Pantheon, 1985), and Archie Hobson, ed., *Remembering America: A Sampler of the WPA American Guide Series* (New York: Columbia University Press, 1985). For an academic treatment, see Christine Bold, *WPA Guides: Mapping America* (Jackson: University Press of Mississippi, 1999). David A. Taylor, *Soul of a People: The WPA Writers' Project Uncovers Depression America* (Hoboken, NJ: John Wiley and Sons, 2009) presents a new overview of the project and accompanies a documentary of the same name. There has also been renewed attention to these guides in the press, with a series of travel articles in the *New York Times* that retraces the recommendations set out in them (see, for example, William Yardley, "Going Down the Road: Places Captured in Time, But Not Frozen There," about Washington state, *New York Times*, July 15, 2008). The guides have also served as inspiration for a compendium of original essays by contemporary writers based on states, edited by Matt Weeland and Sean Wilsey, *State by State: A Panoramic Portrait of America* (New York: Ecco Press, 2008).

18. The political emphasis of the era has been well covered, including notable studies such as Michael Denning, *The Cultural Front: The Laboring of American Culture in the Twentieth Century* (New York: Verso, 1997); Lewis Erenberg, *Swingin' the Dream: Big Band Jazz and the Rebirth of American Culture* (Chicago: University of Chicago Press, 1998); and Lary May, *The Big Tomorrow* (Chicago: University of Chicago Press, 2000). For an overview of the historiography of the cultural history of the period, see my "Politics and Culture in the 1930s and 40s" in *A Companion to American Cultural History*, Karen Halttunen, ed. (Malden, MA: Blackwell, 2008), 214–229.

19. A search in the online catalog (available at http://www.loc.gov/rr/print/) provides a cursory view of the dominance of certain cities based on the number of photos designated by location. A search for Baltimore returns 1,669 photographs; Philadelphia, 342; San Francisco, 252; and Topeka, 210, for example. Some of this disparity

can be attributed to the dominance of some cities in the wartime industry (Baltimore was vital in shipbuilding), but it is hard to account more definitively for differences beyond that.

20. My own search through the collection concentrated on those photographs held at the Library of Congress in Washington, D.C., even though smaller collections exist in state archives. I looked both through the online catalog, where one can target a specific location, as well as through the physical files at the Library of Congress. I devised a list of representative cities throughout the country, attempting to cover all regions and cities both growing and waning. From this broad swath, thematic categories emerged, prompting a more in-depth search for those images that best captured that particular element of urbanization.

21. *Cincinnati: A Guide to the Queen City and Its Neighbors* (Cincinnati: Wiesen Hart Press, 1943), xxii–xxiii.

CHAPTER ONE. INTERSECTION

1. *Washington: City and Capital* (Washington, DC: U.S. Government, 1937), 89.
2. Letter from John Vachon to Millicent (Penny) Vachon, 2 July 1941, reprinted in Orvell, *John Vachon's America,* 179.

CHAPTER TWO. TRAFFIC

1. Shooting script reprinted in Garver et al., *Just Before the War,* 9.
2. Weisberger, *WPA Guide to America,* 57.
3. Lynd and Lynd, *Middletown in Transition,* 435.
4. *Atlanta: A City of the Modern South* (New York: Smith & Durrell, 1942), xvi.
5. *Washington,* 112.
6. Shooting script reprinted in Garver et al., *Just Before the War,* 11.
7. Interview with Tom Nolan, New York, 6 February 1939, American Life Histories: Manuscripts from the Federal Writers' Project, 1936–1940. Available at http://memory.loc.gov/wpaintro/wpahome.html.

CHAPTER THREE. HIGH LIFE AND LOW LIFE

1. Interview with Philip Marcus, Chicago, 18 May 1939, American Life Histories: Manuscripts from the Federal Writers' Project, 1936–1940. Available at http://memory.loc.gov/wpaintro/wpahome.html.
2. *San Francisco: The Bay and Its Cities* (New York: Hastings House, 1941), 112.
3. Alfred O. Philipp, "Vaudeville in Chicago," 14 June 1939, American Life Histories: Manuscripts from the Federal Writers' Project, 1936–1940. Available at http://memory.loc.gov/wpaintro/wpahome.html.

CHAPTER FOUR. THE CITY IN THE COUNTRY

1. *A South Dakota Guide* (Pierre: State of South Dakota, 1938), 5.

2. In *Portrait of a Decade,* Hurley notes that from 1937 to 1942 the focus of the FSA extended even to the city, as Stryker and others recognized "that many rural people were moving to urban centers, bringing rural problems and attitudes with them" (95, 100).

3. *Texas: A Guide to the Lone Star State* (New York: Hastings House, 1940), 72; map, 66–67.

4. *Cincinnati,* 131.

5. Weisberger, *WPA Guide to America,* 176.

6. Letter from John Vachon to Millicent (Penny) Vachon, 29 October 1938, reprinted in Orvell, *John Vachon's America,* 145–147.

7. Interview with Sarah Hartje, 9 January 1939, American Life Histories: Manuscripts from the Federal Writers' Project, 1936–1940. Available at http://memory.loc .gov/wpaintro/wpahome.html.

8. *Texas,* 52.

9. *South Dakota Guide,* 6.

10. *Texas,* 115.

CHAPTER FIVE. CITIZENS

1. Interview with Fermin Souto, no date, no place given [probably Tampa, Florida], American Life Histories: Manuscripts from the Federal Writers' Project, 1936–1940. Available at http://memory.loc.gov/wpaintro/wpahome.html.

2. Weisberger, *WPA Guide to America,* 113.

3. Letter from John Vachon to Millicent (Penny) Vachon, 10 October 1938, reprinted in Orvell, *John Vachon's America,* 136. Orvell notes that Vachon's interest in and photographic attention to African Americans was an exception to the dominant vision of the FSA, which largely favored pictures of white Americans (23).

4. Julia M. Sample, "[Here We Can Be Glad #7]," 2 March 1939, American Life Histories: Manuscripts from the Federal Writers' Project, 1936–1940. Available at http://memory.loc.gov/wpaintro/wpahome.html.

5. *San Francisco,* 95.

6. Lynd and Lynd, *Middletown in Transition,* 467.

7. Weisberger, *WPA Guide to America,* 126.

INDEX